HOW TO DRAW WIZARDS, WARRIORS, ORCS AND ELVES

STEVE BEAUMONT

CHARTWELL
BOOKS, INC.

This edition printed in 2007 by
CHARTWELL BOOKS, INC.
A Division of BOOK SALES, INC.
114 Northfield Avenue
Edison, New Jersey 08837

Copyright © 2006 Arcturus Publishing Limited
26/27 Bickels Yard, 151–153 Bermondsey Street,
London SE1 3HA

ISBN-13: 978-0-7858-2345-2
ISBN-10: 0-7858-2345-X

Illustrator: Steve Beaumont
Editor: Rebecca Gerlings
Designer: Emily Gibson

Printed in China

CONTENTS

INTRODUCTION

If you've picked up this book, you are probably a big fan of sword and sorcery movies, books or games, or all of them combined. If you're one of those fans who enjoy the genre so much that you have a desire to create your own imagery of magical wizards casting spells and summoning demons, noble warriors battling it out with demonic beasts or mystical elves in enchanted forests, then this book will help to get you started on the right path.

One of the best things about drawing heroes, villains and fantasy landscapes is that, besides the basic rules of anatomy and perspective, there are no other rules. In fantasy art, no one can tell you that the sword you have drawn is incorrect or that the castle you have drawn wouldn't stand upright because it is not built properly or that the beast you have created is wrong because, in reality, none of it exists. It's a creation of your own imagination … and that's where the fun lies.

This book will introduce you to some of the most popular characters found in the world of fantasy art, such as wizards, warriors, orcs, elves, kings, beasts, and even talks you through designing your own fantasy worlds.

So, without further ado, let's send you off on a magical journey where you get to create fantasy art of your own.

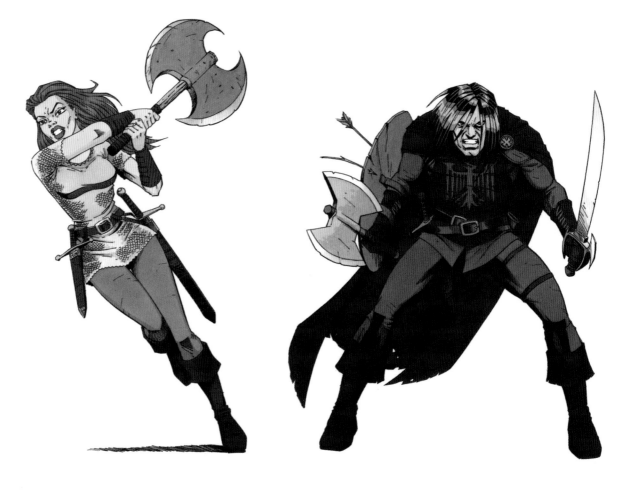

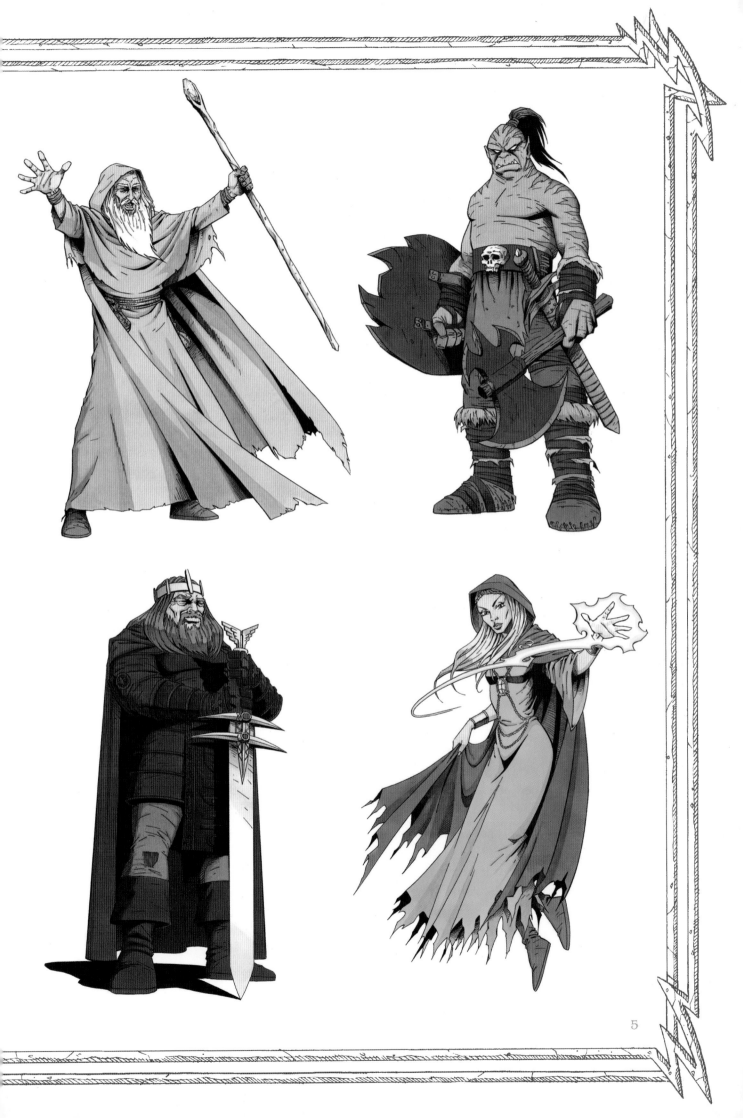

TOOLS

Okay, let's start with the essential tools of the trade because, without them, your pictures just would not be possible.

LAYOUT PAPER
Artists, both as professionals and students, rarely produce their first practice sketches on the best quality art paper, so it is a good idea to buy A4 or A3 paper (whichever you prefer) from a stationery shop, as this is an inexpensive way of practising sketching and creating experimental doodles. Go for the least expensive kind. Most professional illustrators use cheaper paper for basic layouts and to practise sketching before they approach the more serious task of producing a masterpiece on more costly material.

CARTRIDGE PAPER
You don't have to buy the most expensive brand, a medium quality will do. Most decent art or craft shops will stock their own brand range or student range and, unless you're thinking of turning professional, these will do fine.

WATERCOLOUR PAPER
Most art shops will stock a large range of weights and sizes, 250 g/m or 300 g/m is fine.

LINE ART PAPER
This is generally considered for more professional use, but if you just want to practise black and white ink drawing, line art paper enables you produce a clear, crisp line, which is superior to that on cartridge paper because it has a much smoother surface.

PENCILS
It's best not to skimp on quality here. Get a good range of graphite (lead) pencils ranging from soft (6B) to hard (2H).

Hard lead pencils last longer and leave fewer smudges on your paper; soft-leaded ones leave darker marks on the paper and wear down more quickly. Every artist has their personal preference, but 2H pencils are a good medium-range product to start with.

Spend some time drawing with each weight of pencil, so you become used to the different qualities. Another good product is the clutch, or mechanical, pencil. These are available in a range of lead thicknesses, 0.5 mm being a good middle range. This product is very good for fine detail work.

PENS

There is a wide range of good-quality pens on the market these days. All will do a decent job of inking.

It's important to experiment with different pens to determine which you find most comfortable to work with. You may find that you end up using a combination to produce your finished artwork. Also, remember to use a pen that contains waterproof ink if you want to colour your illustration with a watercolour or an ink wash. It's good to use one of these anyway, as there's nothing worse than having your nicely inked drawing ruined by an accidental drop of water…

BRUSHES

Some artists like to use a fine brush for inking line work. This takes a bit more practice and patience to master, but the results can be very satisfying. If you want to try your hand at brushwork, you will definitely need to get hold of some good-quality sable brushes.

ERASER

There are three types of eraser: rubber, plastic and putty. Try all three to see which you prefer.

MARKERS

These are very versatile pens and with practice can give very pleasing results.

WATERCOLOURS AND GOUACHE

Most art stores will also stock a wide range of these products from professional to student quality.

INKS

With the dawn of computers and digital illustration, materials such as inks have become a bit obscure, although most good art or design stores do still stock them.

Oh, and you may need a tool for sharpening your pencils…

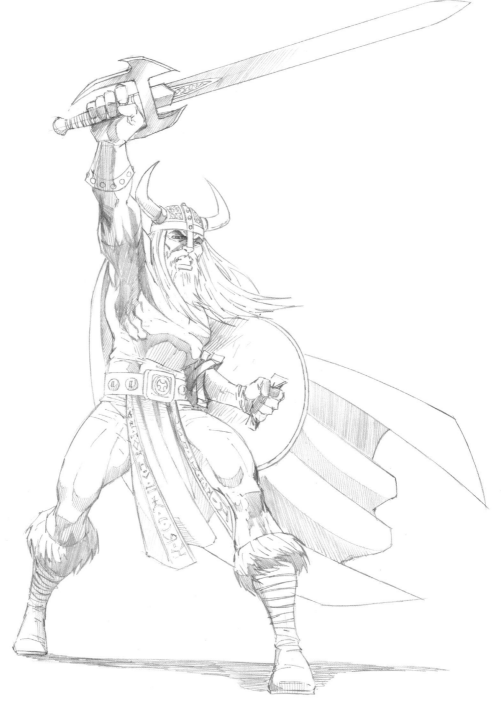

Here's a pencil drawing of a valiant warrior striking a heroic pose. Great! But how do we get from a blank piece of paper to this? The answer lies with knowledge of the basic stick figure.

 Learning how to draw the stick figure effectively will determine the outcome of your finished drawing. This is particularly crucial when drawing action scenes, where your figurework needs to be full of energy.

The sketches on this page show the artistic process that resulted in the final drawing you see on the facing page.

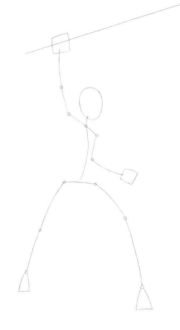

1 First, produce some loose sketches (called thumbnails) to establish the basic shape of the figure, then make a larger drawing of your chosen sketch.

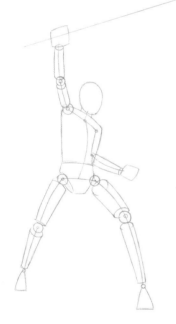

2 Next, flesh out the skeleton with basic shapes (this process will be discussed later in the chapter).

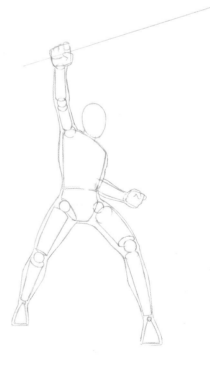

3 Finally, add a smoother finish to the basic stick skeleton. We need go no further as all that needs to be established at this point is the construction process.

BASIC CONSTRUCTION: THE STICK FIGURE IN ACTION

Familiarize yourself with the human form in motion: running, jumping, kicking, brandishing a sword, etc. Notice that all movement has a certain rhythm to it. This should be translated into your stick figurework.

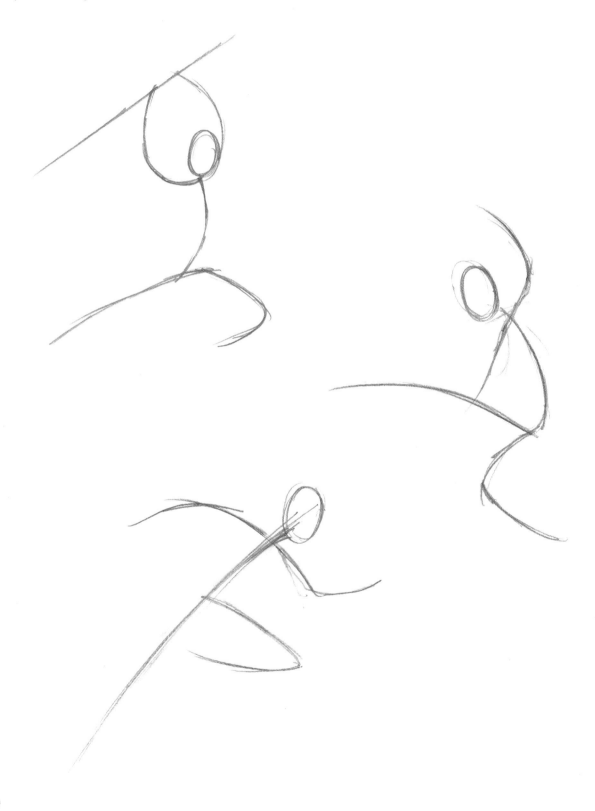

Practise drawing loose, casual lines that flow and give a sense of direction. This is a vital part of the creative process, so it's okay to spend plenty of time on sketching and doodling figurework. The more you do it, the easier it all becomes.

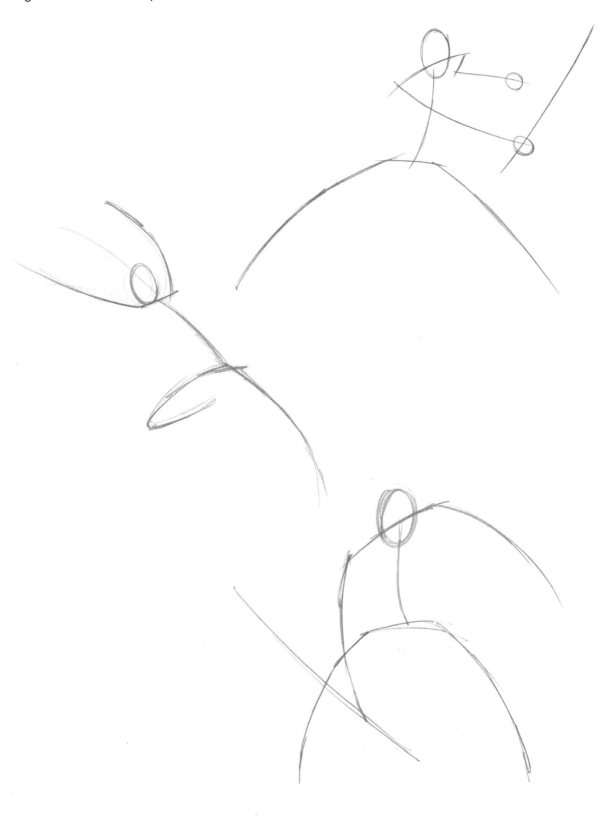

BASIC CONSTRUCTION: SHAPES

The basic construction of the human form can be broken down into cylinders, cubes and spheres.

Anyone who can hold a pencil can draw the basic shapes of squares, triangles and circles, but it's the ability to give form to these shapes that makes them appear more real. Here are some examples:

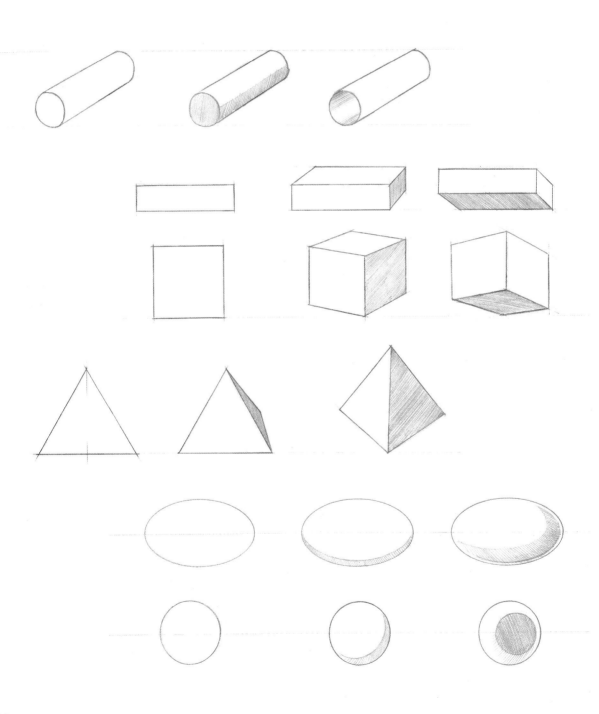

Now let's consider constructing the human form using these basic shapes:

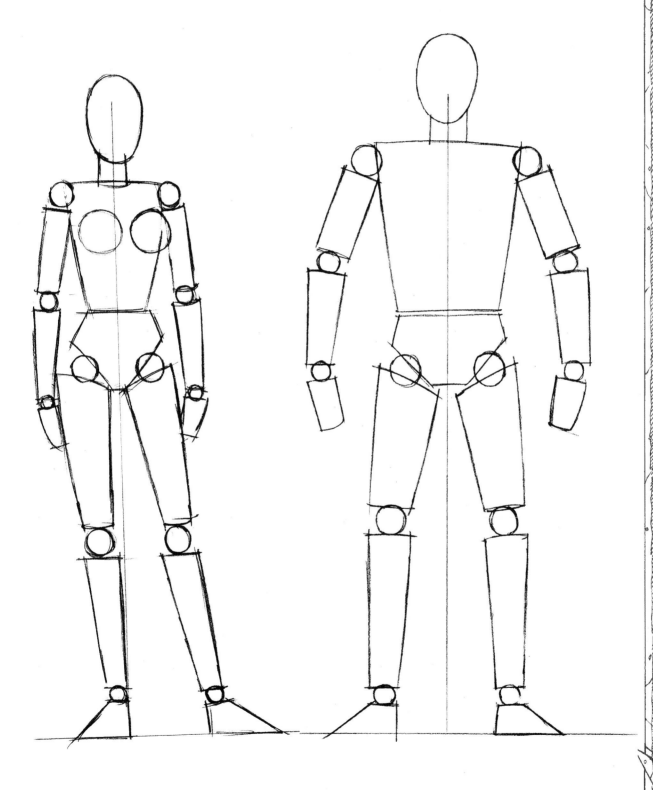

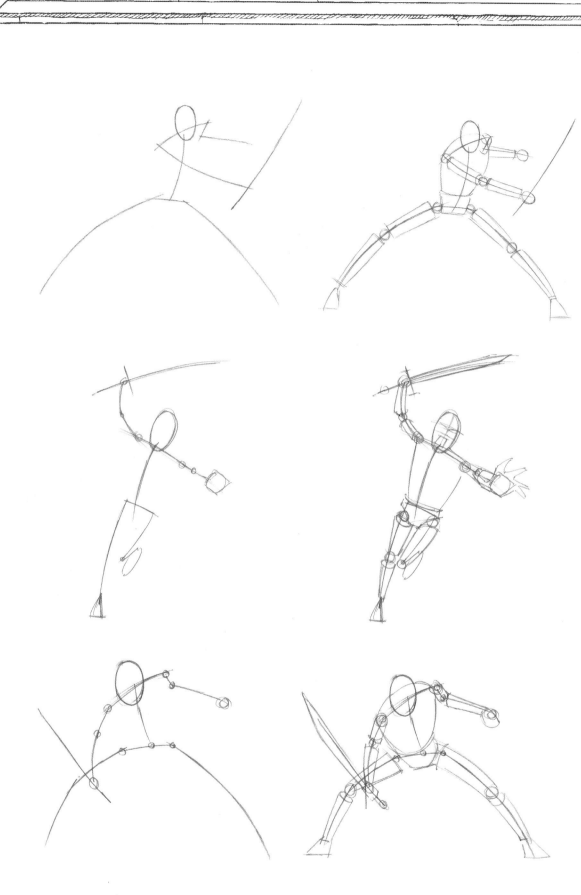

Here's a more dramatic pose that would not be possible without three-dimensional application to the shapes.

CONSTRUCTING THE FACE

The human head generally fits into a square. Note that the nose and chin protrude slightly. It may help to divide the square into quarters. The eyes generally sit halfway above the centre line, with the nose taking up half the depth of the bottom square. Note the alignment of the ears in relation to the eyes and nose. This

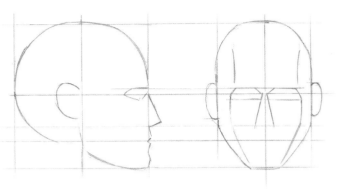

example is based on a standard-sized head – of course, there will be situations when it may be necessary to adjust this formula.

Throughout this book, we'll be looking at various characters. Each of them will have different-sized heads and their own facial features and expressions. Before we move on to those, let's take a quick look at some examples of different facial features:

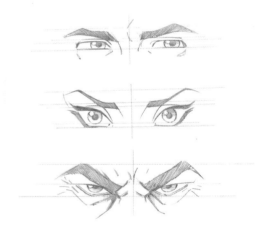

EYES
These eyes are serious-looking, but not scary. They look as though they would sit well on the face of a hero.

These eyes are clearly feminine, so no prizes for figuring out to whom they belong.

Whoa! These eyes are definitely not inviting you over for dinner, unless of course you happen to be on the menu. These would look right for an orc.

MOUTHS
Study these simple drawings of mouths. Note how the male and female mouths differ. A simple way of establishing the sex of a character facially is to keep the mouth of the male simple, without lips (don't worry, this will look fine), and to draw full lips on the female. It also helps to make male characters' mouths bigger than those of females. No need for any such refinement in the last example, just cram that vast chasm with sharp teeth!

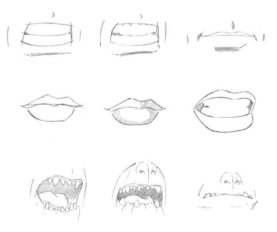

Let's take a look at some of these faces and note how they differ from one another:

WIZARDS
Generally, these guys are going to be ancient-looking as they will have spent a lifetime devoting themselves to the mystical art of sorcery. Some of them may be a few hundred years old, so make sure that they don't look younger than 60. A long, thin face with plenty of creases and, of course, a nice long beard are good starting points.

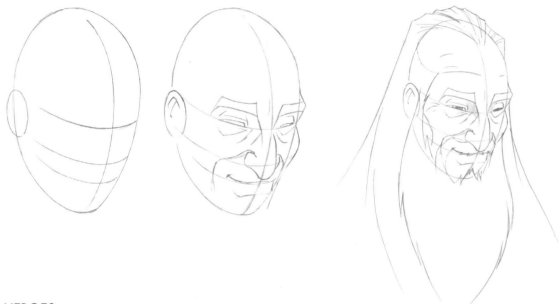

HEROES
These will come in all shapes and sizes as we'll establish later in the book, but for now we'll use this example. The best-loved heroes are rugged and handsome so let's go for a broader shaped head and a good, square jaw.

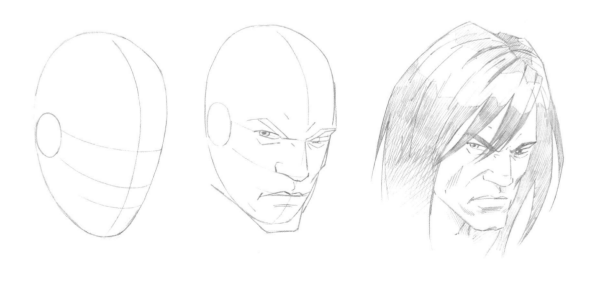

HEROINES

Yep, girls can swing swords and axes along with the best of them. Just as we like our heroes handsome, we like our heroines to be attractive, if not beautiful. So the key here is thinner and more refined.

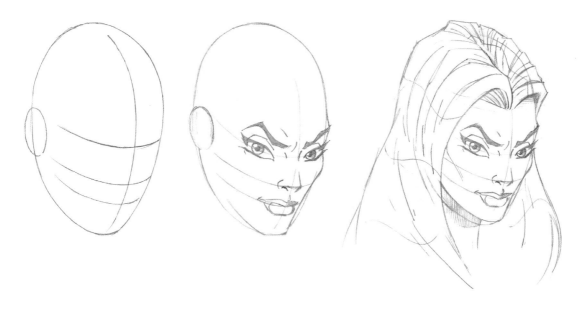

DWARVES

These guys have shorter and wider heads than the handsome hero type, but let's not forget that as warriors in fantasy art they are just as important, so care must be taken to make sure that they have a charm all their own.

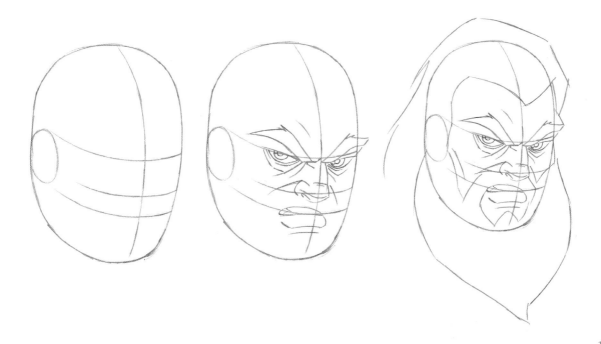

ELVES

Note the refined, slender features of this delicate fantasy race.

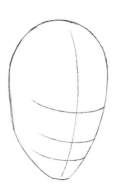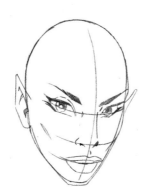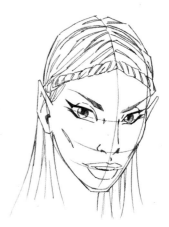

ORCS

Let's take a look at this classic brute — note the big head and low forehead (indicators of the very small brain inside), and don't forget the mouth full of sharp teeth. To sum him up, he's just plain ugly!

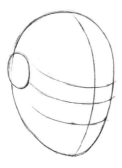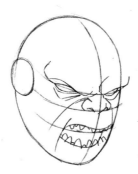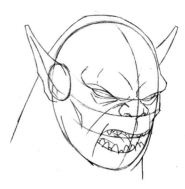

Here we have a smaller, thinner variation on the face above, featuring a hooked nose and beady eyes, giving this beast an even more sinister appearance.

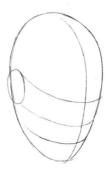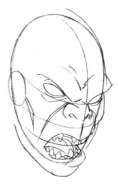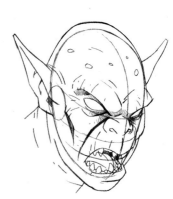

HANDS

Before we move on to constructing the full figure in action, let's take a quick look at the hands and feet. This will help you when you come to draw full figures in different action poses.

A good way of becoming better acquainted with this part of the anatomy is to practise drawing your own hand in different positions. You'll be surprised at how quickly this will help you to improve your drawing skills. Essentially, the palm is square-ish. Split the fingers into three sections (as indeed they are), and the thumb too, the base of which is a larger, triangular shape. This does not reflect a true human skeleton, but it does help when sketching hand movements.

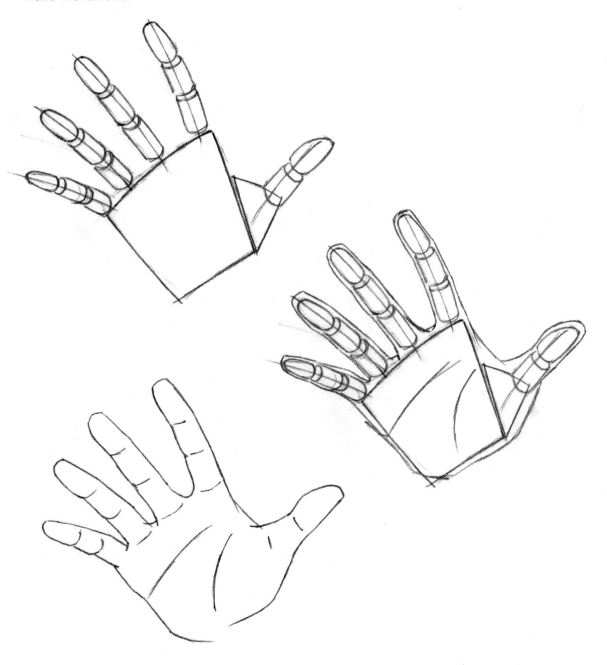

FEET

This is a part of the body that a lot of artists struggle with during the early stages.
However, it's a shame to ruin a perfectly good drawing because of a lack of understanding
of the basic construction. In most cases, just think of the foot as a sort of triangular shape.
Use these examples as a guide:

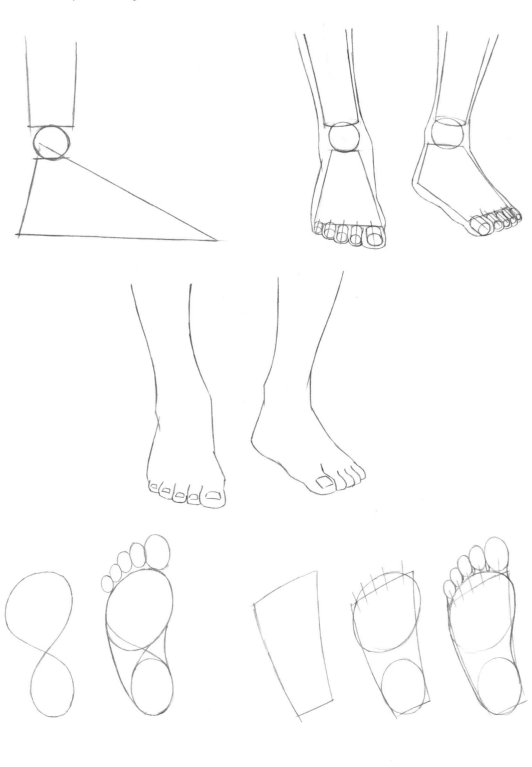

WIZARDS

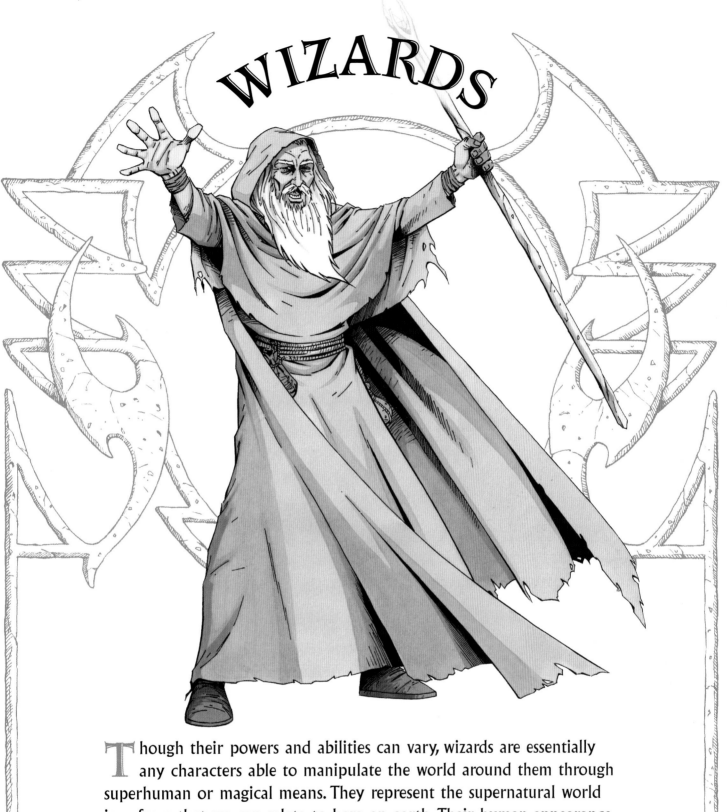

T hough their powers and abilities can vary, wizards are essentially any characters able to manipulate the world around them through superhuman or magical means. They represent the supernatural world in a form that we can relate to here on earth. Their human appearance – usually that of a wise old man – helps to form a bridge between our world and that of magic and sorcery.

WIZARDS

DRUID

Druids generally work for the greater good, as opposed to sorcerers, who immerse themselves in works of evil. They devote their lives to the pursuit of knowledge, truth and the harnessing of cosmic energy.

1 Let's start with the basic stick figure.

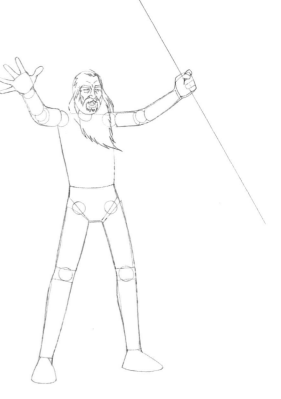

2 Apply the basic shapes around the stick frame.

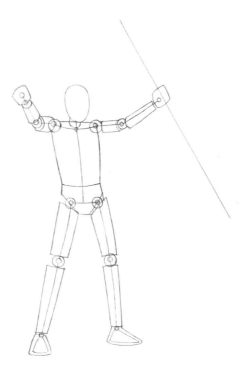

3 Finally, give the head some features, as mentioned earlier in the book. Wizards tend to look a bit on the ancient side, so give him a thin, scraggy face and a big, white beard. Draw the outer form over the basic shapes to give a more realistic appearance.

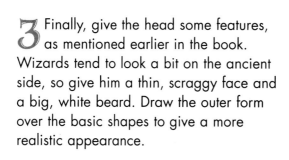

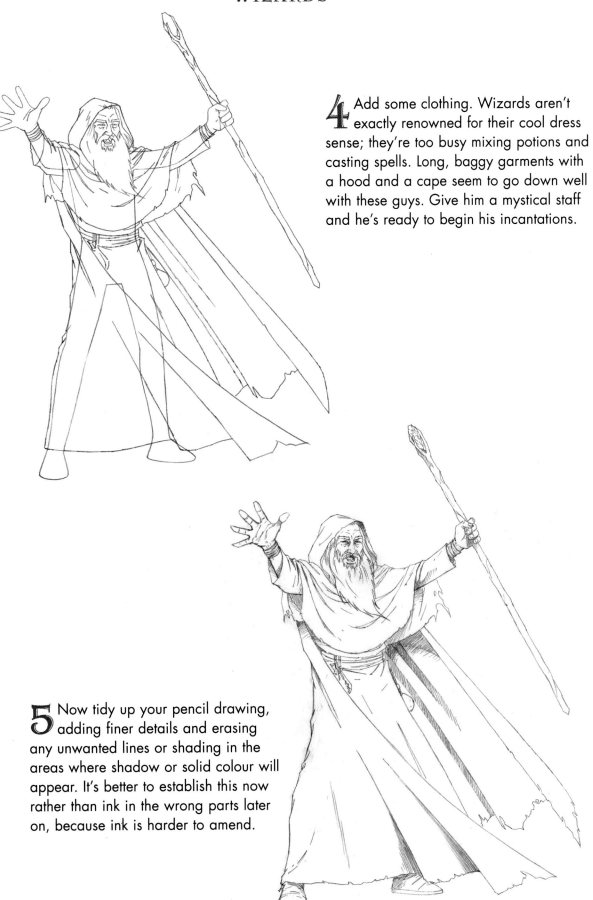

4 Add some clothing. Wizards aren't exactly renowned for their cool dress sense; they're too busy mixing potions and casting spells. Long, baggy garments with a hood and a cape seem to go down well with these guys. Give him a mystical staff and he's ready to begin his incantations.

5 Now tidy up your pencil drawing, adding finer details and erasing any unwanted lines or shading in the areas where shadow or solid colour will appear. It's better to establish this now rather than ink in the wrong parts later on, because ink is harder to amend.

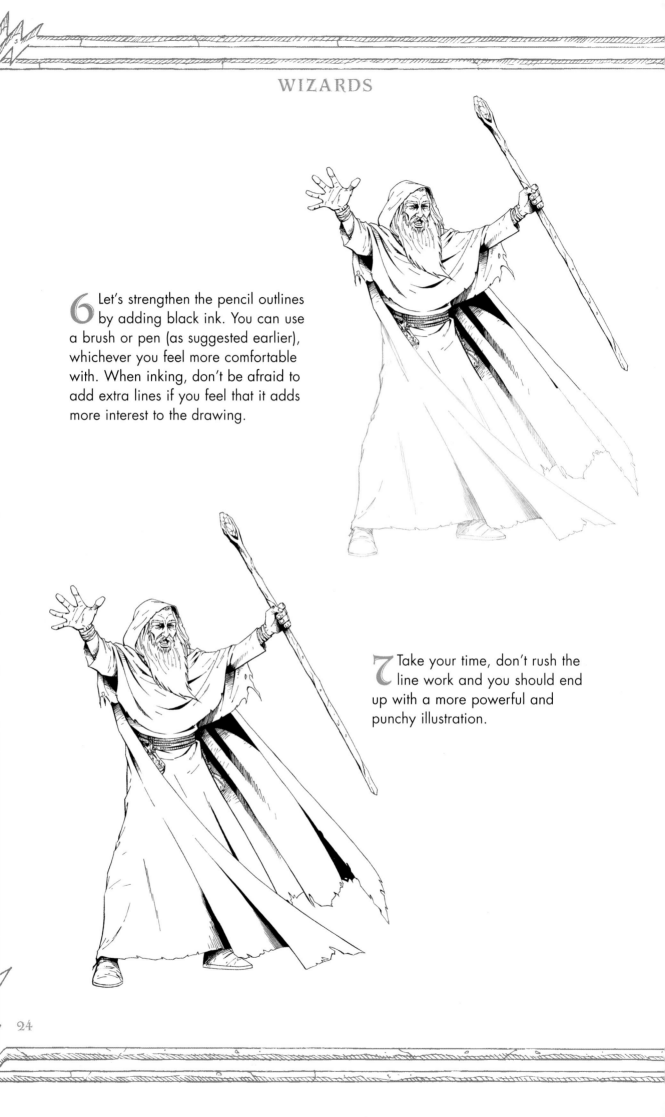

6 Let's strengthen the pencil outlines by adding black ink. You can use a brush or pen (as suggested earlier), whichever you feel more comfortable with. When inking, don't be afraid to add extra lines if you feel that it adds more interest to the drawing.

7 Take your time, don't rush the line work and you should end up with a more powerful and punchy illustration.

8 Here's what the finished colour illustration will look like. We'll be covering different colouring techniques later in the book. You can then refer back to this page later for colour schemes or, if you simply can't wait, jump to page 142 for some colouring tips.

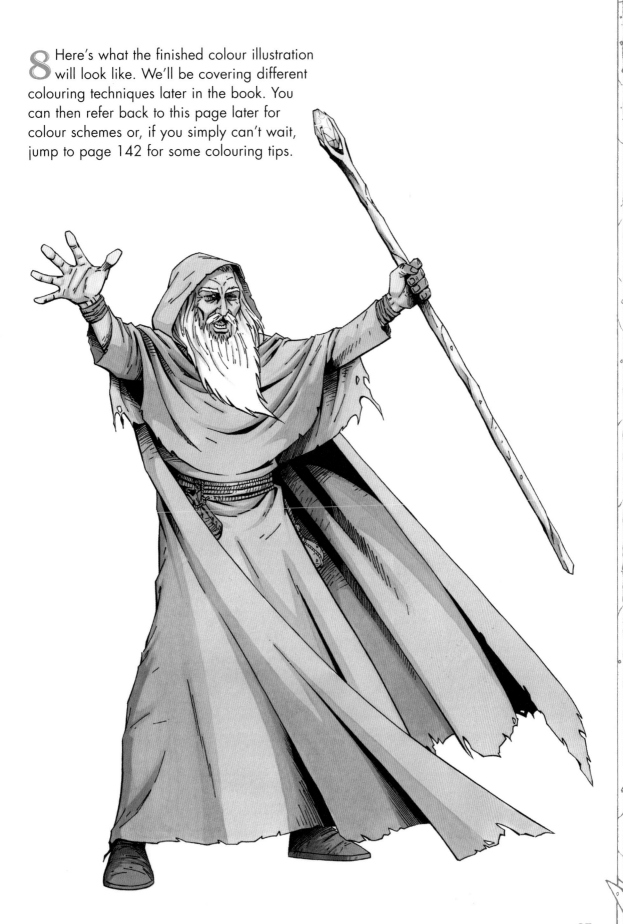

EVIL WIZARD

Evil wizards (or sorcerers) use their magical powers for thwarting good. This particular wizard is definitely not the sort of character you'd want to cross.

1 As always, we start with the stick figure.

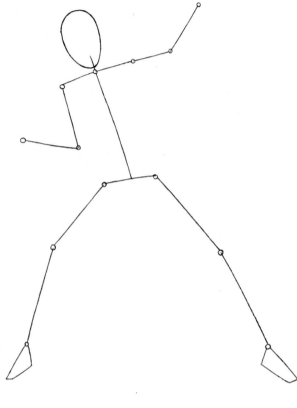

2 Add shape by utilizing the techniques described on pages 12–13.

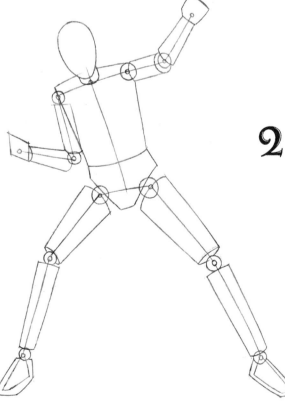

3 Let's give this character some identity by drawing his face. This guy is evil, so convey this trait with narrow, cruel-looking eyes. We'll give him a beard and straggly hair for a more sinister look.

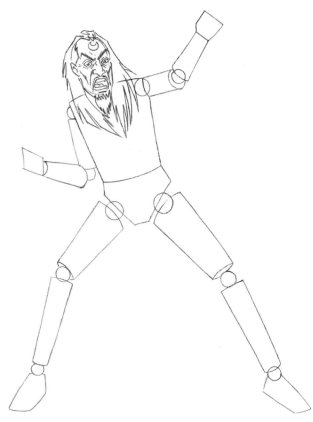

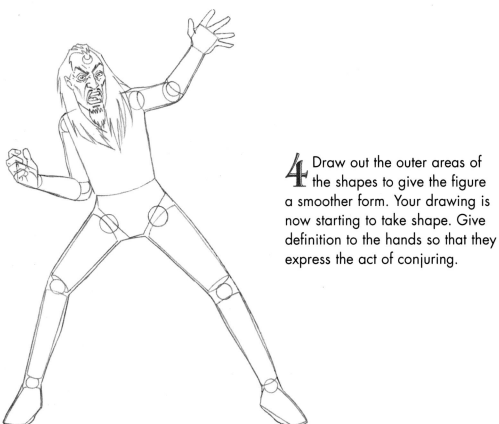

4 Draw out the outer areas of the shapes to give the figure a smoother form. Your drawing is now starting to take shape. Give definition to the hands so that they express the act of conjuring.

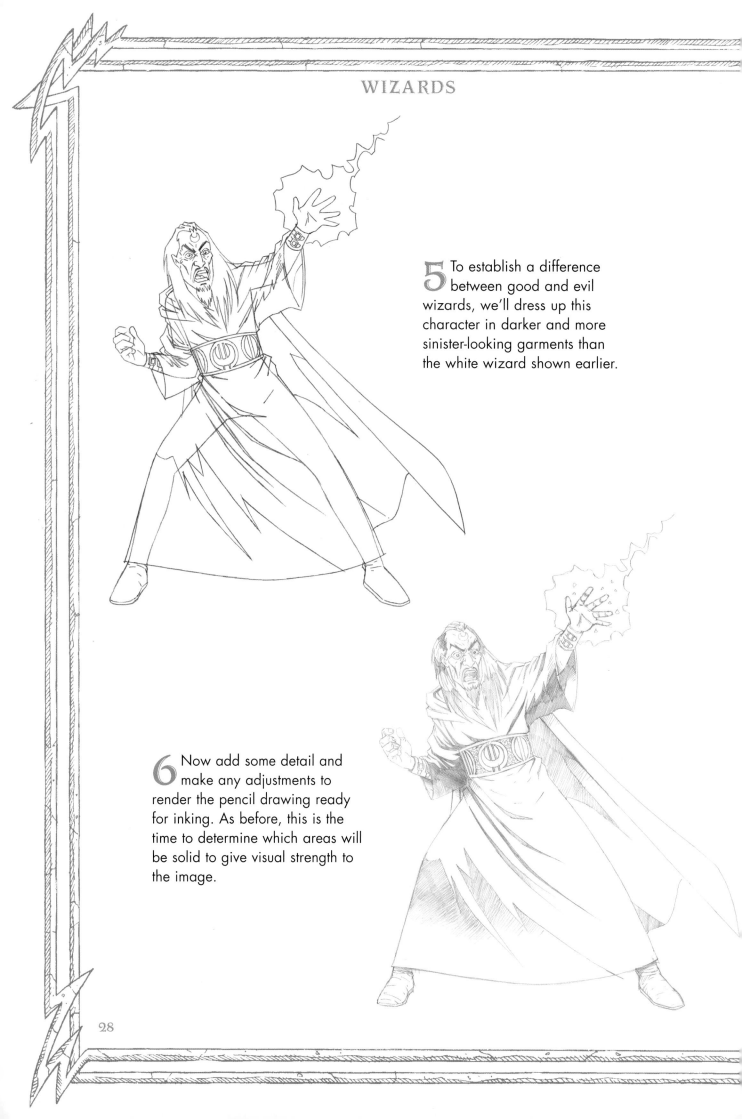

5 To establish a difference between good and evil wizards, we'll dress up this character in darker and more sinister-looking garments than the white wizard shown earlier.

6 Now add some detail and make any adjustments to render the pencil drawing ready for inking. As before, this is the time to determine which areas will be solid to give visual strength to the image.

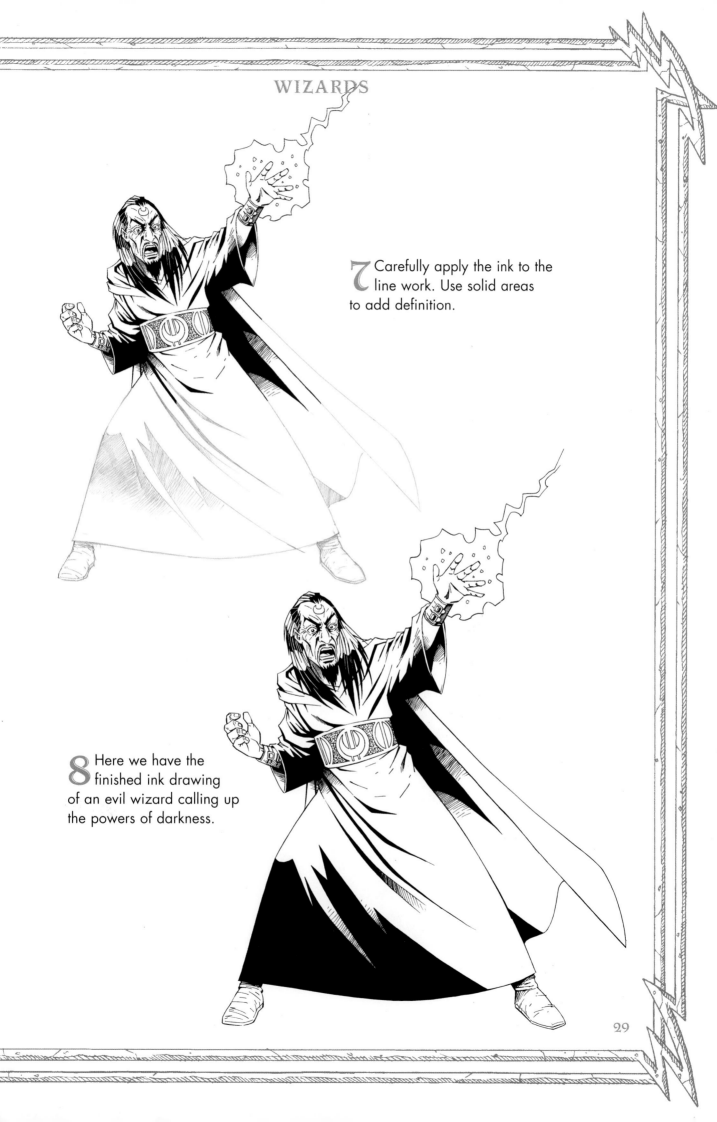

7 Carefully apply the ink to the line work. Use solid areas to add definition.

8 Here we have the finished ink drawing of an evil wizard calling up the powers of darkness.

29

9 Another way of establishing the nature of the character is by the use of colour. The use of black to represent evil is commonplace in illustration and cinema. It's okay to use established stereotype concepts to convey your theme. You could also try adding flashes of colour by using dark red and green tones.

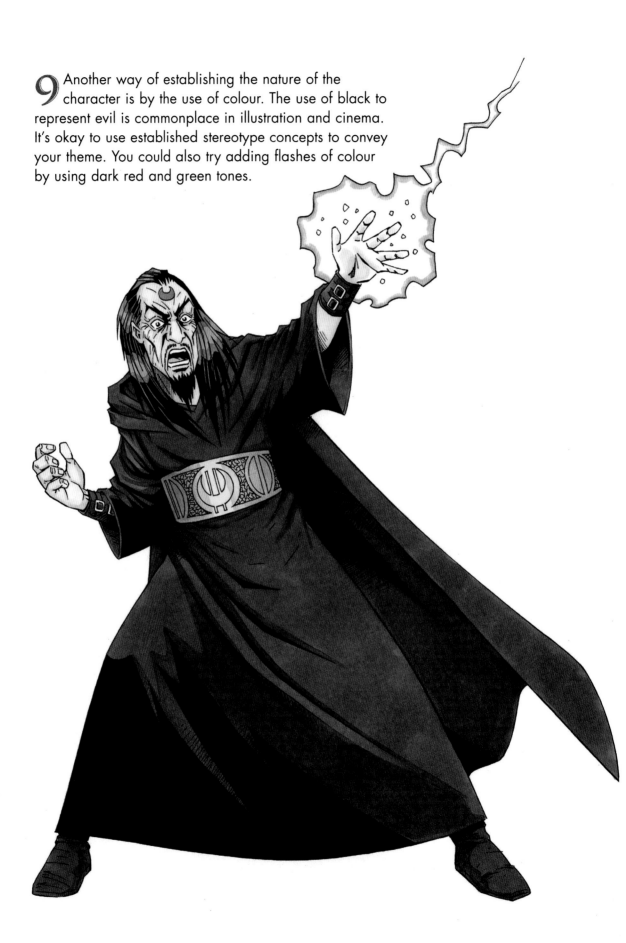

WITCHES

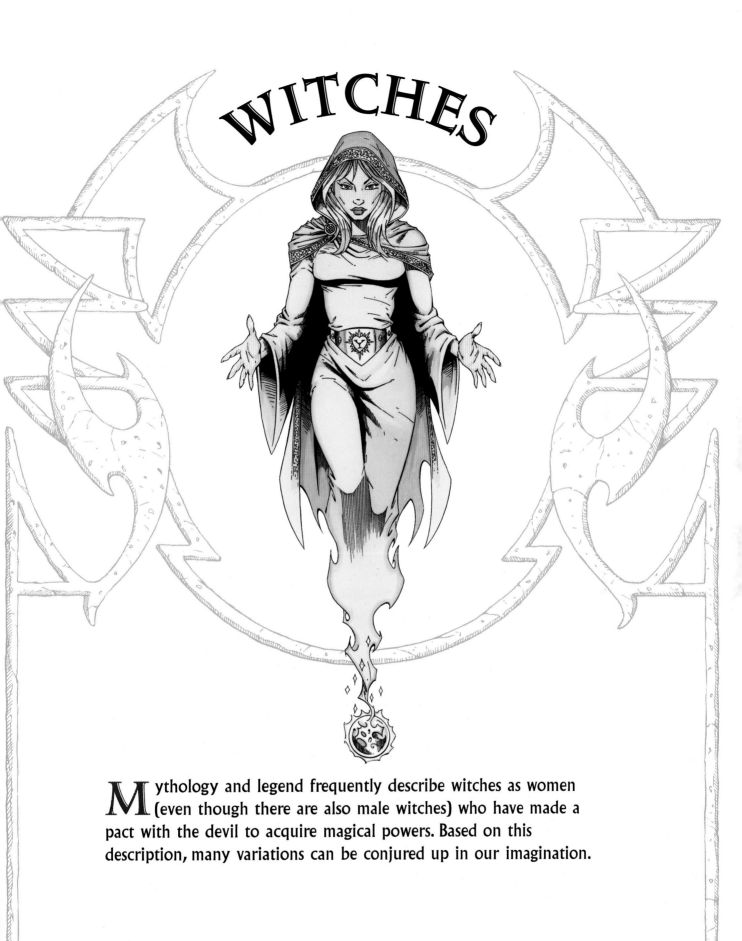

Mythology and legend frequently describe witches as women (even though there are also male witches) who have made a pact with the devil to acquire magical powers. Based on this description, many variations can be conjured up in our imagination.

GOOD WITCH

Witches don't necessarily have to be ugly, as they can use their powers to make themselves appear very attractive, if not beautiful, like this one here.

1 The pose of this character is different from the previous images in that she will be floating (in fact, appearing from mist) and not standing, so the stick figure will take a more unusual shape. Note how the lines are drawn to a point at the bottom just above the crystal ball.

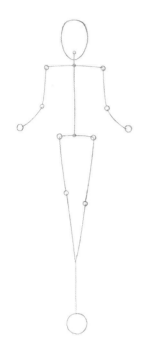

2 Add body shape to the stick figure. There is no need for feet because she will only appear solid from the knees up.

3 Put in the facial features. Make them a stark contrast to the ugliness of the evil witch. Also add the outer body form over the shapes.

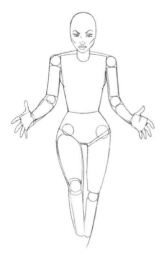

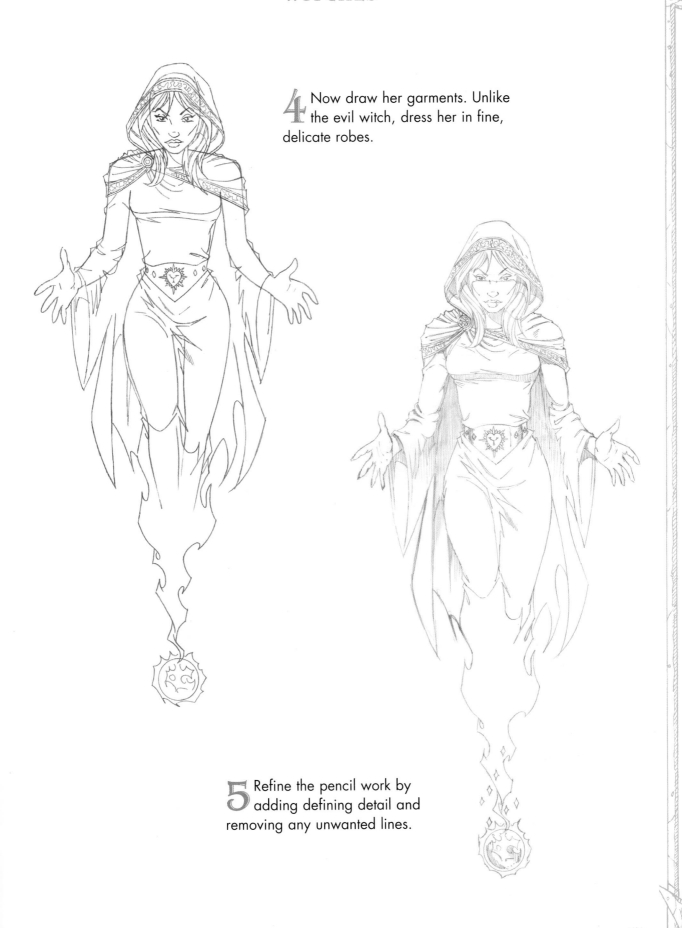

4 Now draw her garments. Unlike the evil witch, dress her in fine, delicate robes.

5 Refine the pencil work by adding defining detail and removing any unwanted lines.

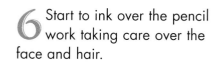

6 Start to ink over the pencil work taking care over the face and hair.

7 If you've kept the line work nice and crisp, you should end up with something quite dramatic.

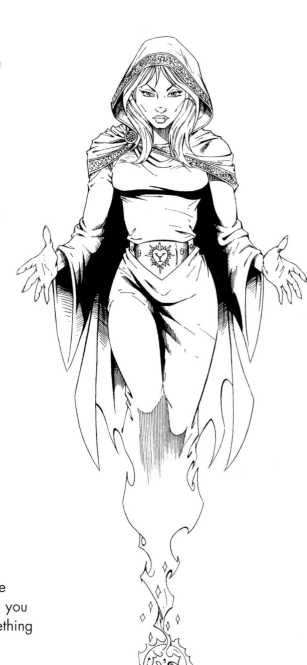

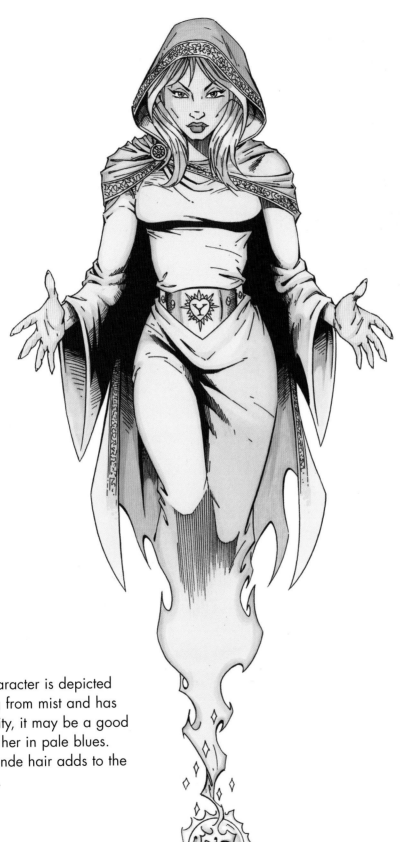

8 As this character is depicted appearing from mist and has a ghostly quality, it may be a good idea to colour her in pale blues. Giving her blonde hair adds to the ethereal effect.

EVIL WITCH

For the purpose of this exercise, let's make this witch look like all hell and fury have broken loose at her command.

1 Use the stick figure to create a dynamic pose.

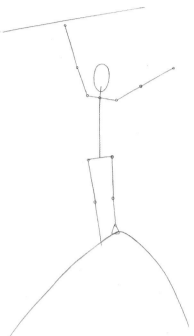

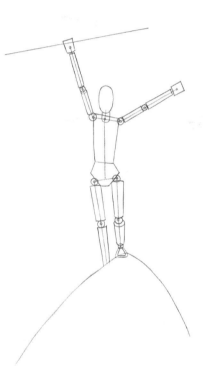

2 Now apply the basic shapes, remembering to use more slender shapes for the female body.

3 Witches are often depicted as nightmarish creatures to be feared, so let's give her a scary face – not necessarily ugly, but definitely scary.

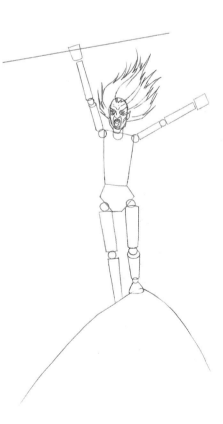

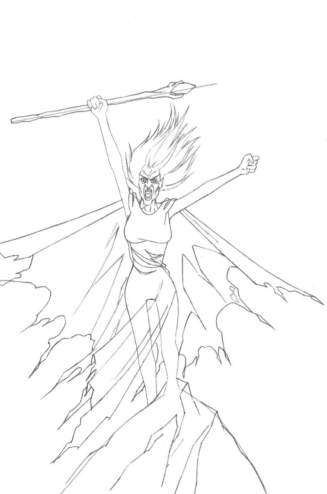

4 Add form over the basic shapes.

5 Another good way of conveying the evil witch's nightmarish overtones visually is to dress her in tattered black robes that flap around as she summons up dark forces for her magic. Witches have all sorts of tools for doing this – let's give this one a mystical staff. It could the bone of a creature (possibly a dragon) or a twisted branch from a magical tree. Give the mound she's standing on some detail, so that it begins to form the top of a high rock or mountain.

6 Add further detail to convey the rugged surface of the rock, the anger in her face and the power of the forces of evil blowing around her.

7 Next, give her some bone bracelets and necklace. Snakes are always a welcome visual aid when creating images of evil so let's place one in her hand, as if she is using it as part of the spell.

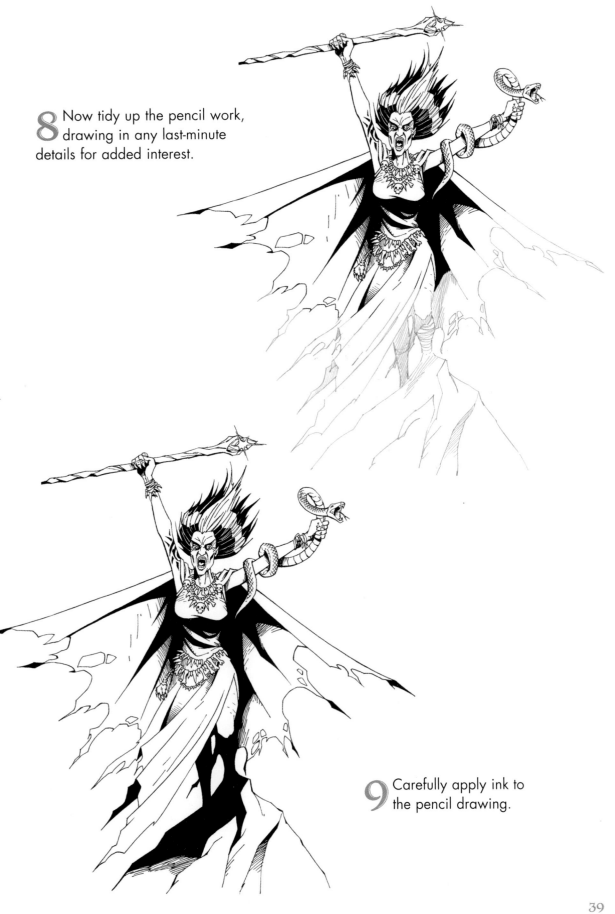

8 Now tidy up the pencil work, drawing in any last-minute details for added interest.

9 Carefully apply ink to the pencil drawing.

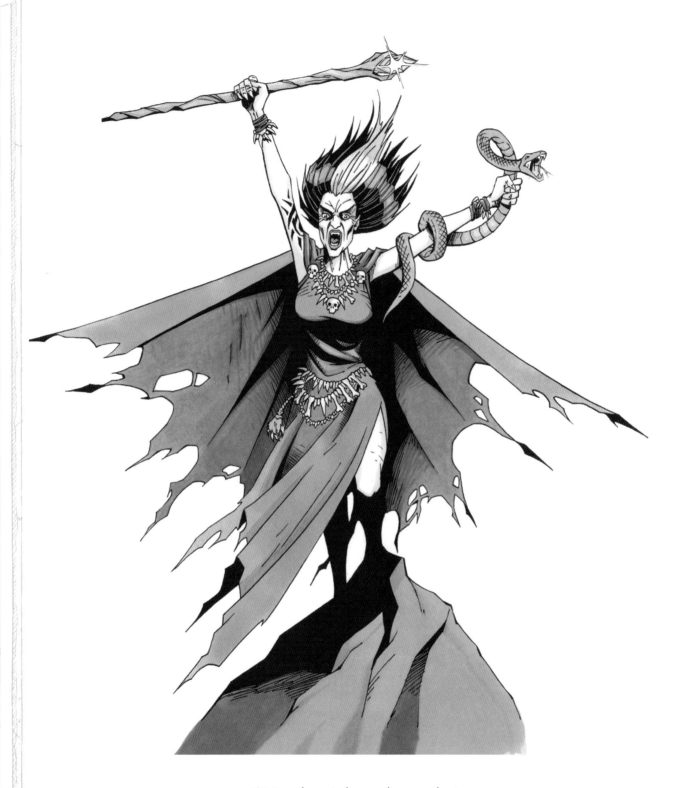

10 Giving the witch a pale complexion makes the darker areas of the image, such as the eyes, mouth and so on, more intense. Adding a slight green hue to the skin will make this character even more nightmarish.

WARRIORS

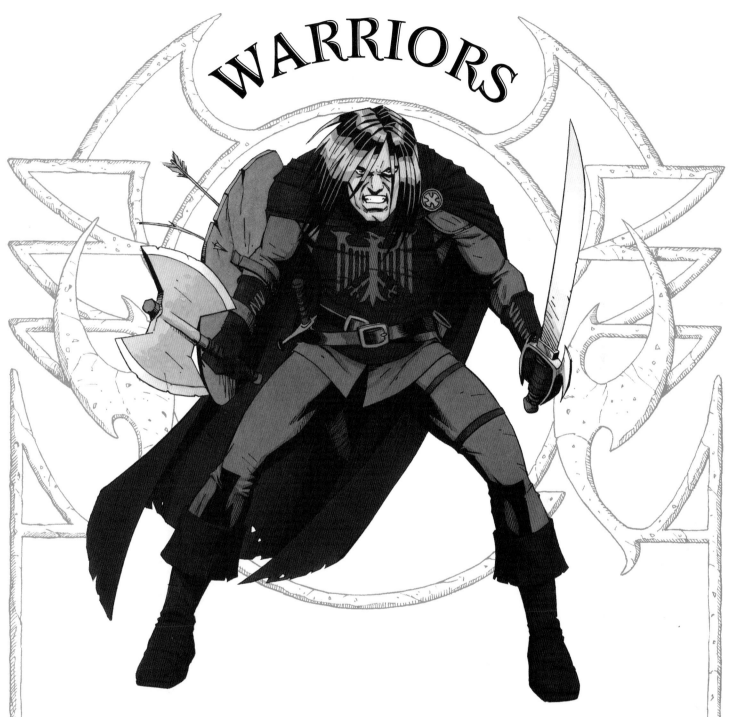

The most interesting heroes are not necessarily handsome (although that often helps, and the examples that follow possess this trait) but are certainly complex and flawed. Many legendary warriors were flawed: Sir Lancelot's weakness was for the wife of the king he served; Samson's weaknesses were women and his pride. Over the next few pages, we will encounter examples who appear to be more anti-hero than hero, but who ultimately fight for the greater good, perhaps sacrificing themselves in the process.

MALE WARRIOR

Although a heroic figure, this type is also bordering on the barbaric. He is a true warrior who lives for the thrill of battle. Muscular and brutish, he will stop at nothing to defeat his oppressor.

1 Start with your basic figure, making it strike an aggressive pose.

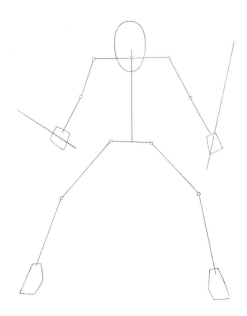

2 Bulk out your stick figure, to create the basis of quite a muscular-looking warrior.

3 Facially, make the warrior look fierce but not ugly. A kind of rugged handsomeness will do, with a good, square jaw and unruly hair.

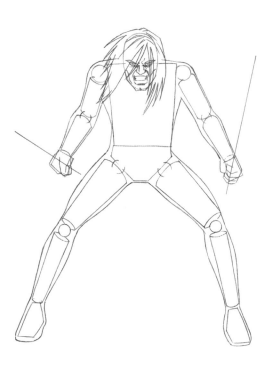

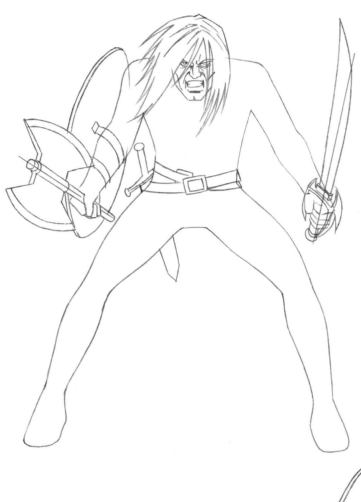

4 Now add weapons such an axe, sabre, shield and belts.

 Dress him in a cape and boots.

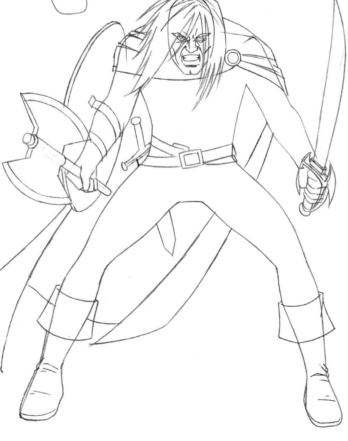

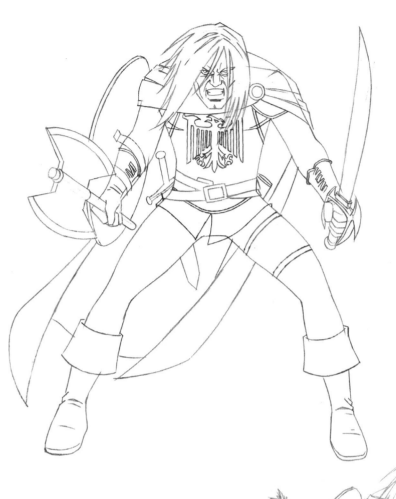

6 Add a leather breastplate with an emblem or insignia on it (design your own, if you wish) and some gloves.

7 Refine the earlier pencil work and shade in further detail.

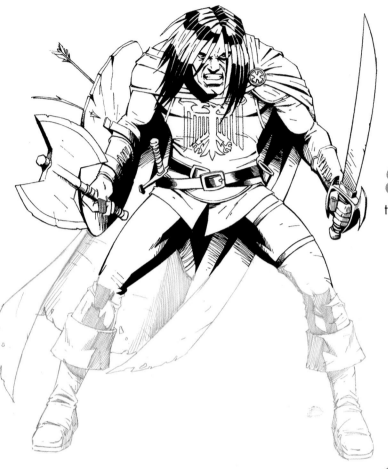

8 Begin adding ink to the pencil work to bring the drawing to life.

9 The areas of solid black represent shadow, contrasting nicely with the detail on the warrior's costume and weaponry.

45

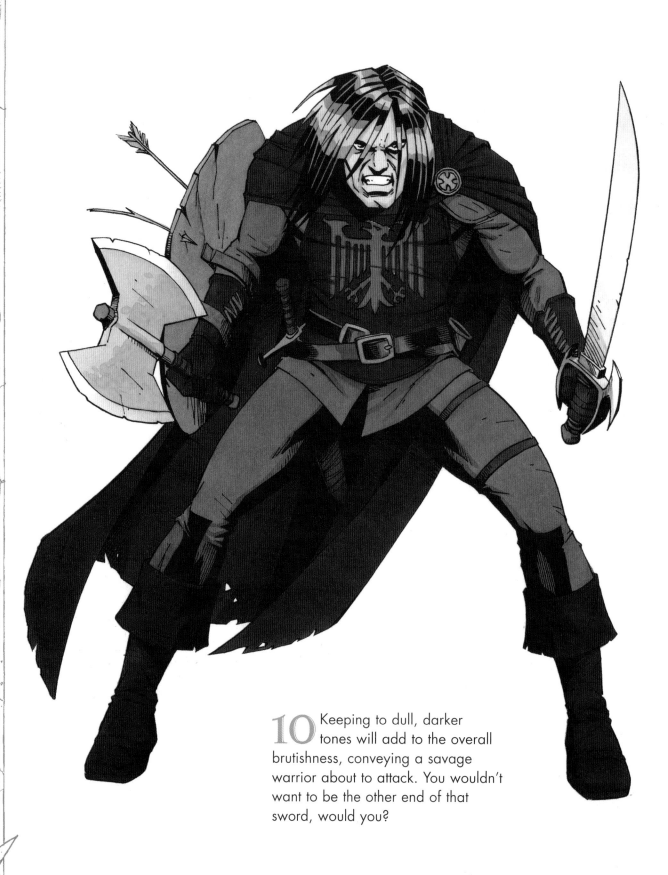

10 Keeping to dull, darker tones will add to the overall brutishness, conveying a savage warrior about to attack. You wouldn't want to be the other end of that sword, would you?

FEMALE WARRIOR

Who says only guys should have all the orc-slaying fun? Oh yes, girls can swing an axe just as well. Just fire one up and you'll find out! History is littered with heroines from Boudicca, Queen of the Britons who rebelled against the Romans, to Joan of Arc, the fearless leader of the French army in 1429, and that's fact, not fantasy!

1 Use a good combat pose to start off your stick figure.

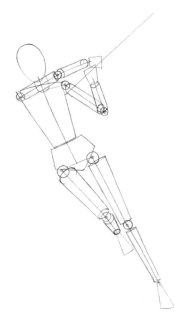

2 Now add some of the basic form shapes.

3 Although she is a warrior who, okay, may not be very ladylike, there's no reason why she can't be good-looking. This is fantasy art so you can draw her exactly as you'd like her to be. Give her shape and definition by adding the outer form.

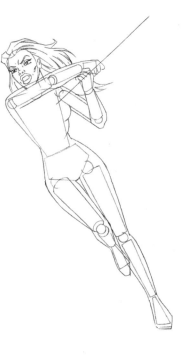

4 Just as her male allies wear breastplates, let's give her some protective gear in the form of a chainmail tunic. Also some boots and leather chaps for her forearms, and a nice big axe, too.

5 Here we have the finished pencil drawing. Note the added detail on the chainmail and the axe handle, boots and hair.

6 Now clean up the line work and carefully ink over the pencil drawing, making sure to keep the lines crisp and clean.

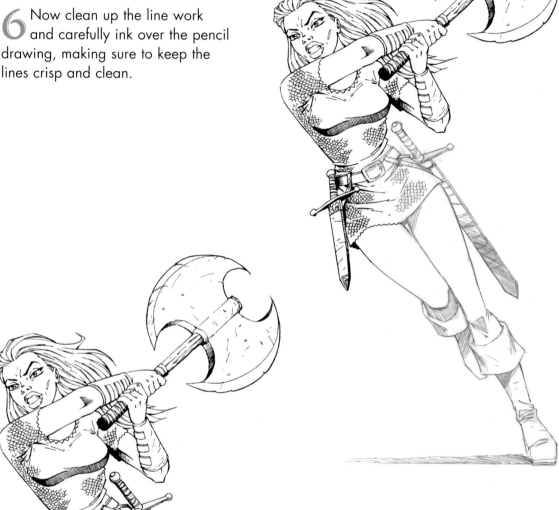

7 Note that the use of solid areas is kept to a minimum and that, although the final ink drawing is strong and dynamic, some delicate line work helps to maintain a feminine look.

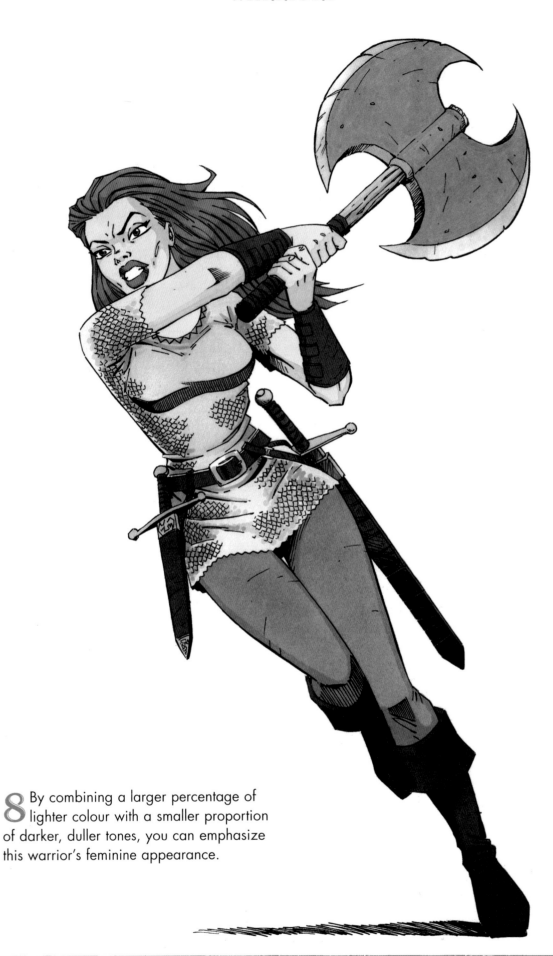

8 By combining a larger percentage of lighter colour with a smaller proportion of darker, duller tones, you can emphasize this warrior's feminine appearance.

MALE WARRIOR ON HORSEBACK

Here we have a warrior who appears more savage than noble – a nomadic warrior on horseback, roaming from kingdom to kingdom in search of adventure.

1 This may seem a difficult task to undertake, but it's far less daunting when reduced to easy stages. Because the skeleton of a horse is not as straightforward as the human skeleton (and not totally essential to producing this image), the horse will be broken down into a frame that's not technically correct, but will make the drawing image much easier.

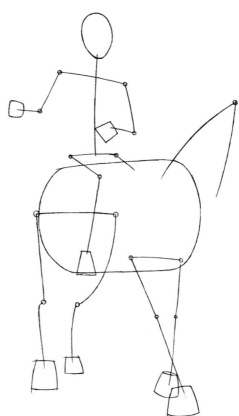

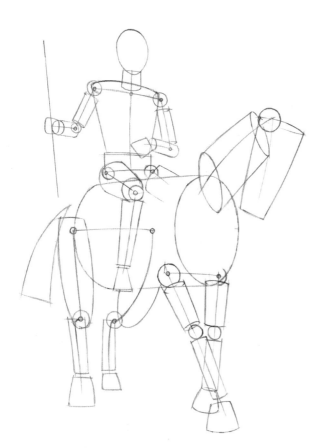

2 Although this composition may seem more complex at first, note how the horse still breaks down into the same basic cylinders and cubes. Also note the longer bulkier shape used for the horse's body and how the legs follow the same ball-joint construction as the human figure. A useful tip for drawing animals is to study photographs of the creature that you wish to draw and practise breaking it down into basic shapes. If the photograph holds no personal value, it also helps to draw these shapes on the actual image.

3 Produce a smoother outer form over the shapes. Narrow eyes and a square jaw create the right mood for this warrior.

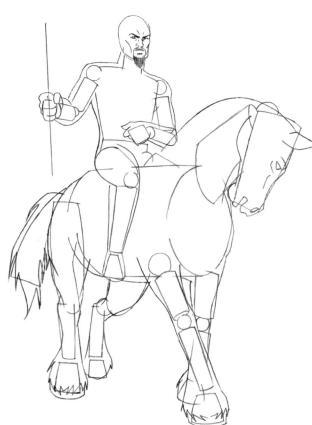

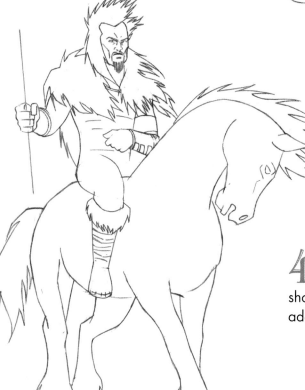

4 Now add a full head of unruly black hair, plus a fur around his shoulders and a leather vest. Also add the horse's mane.

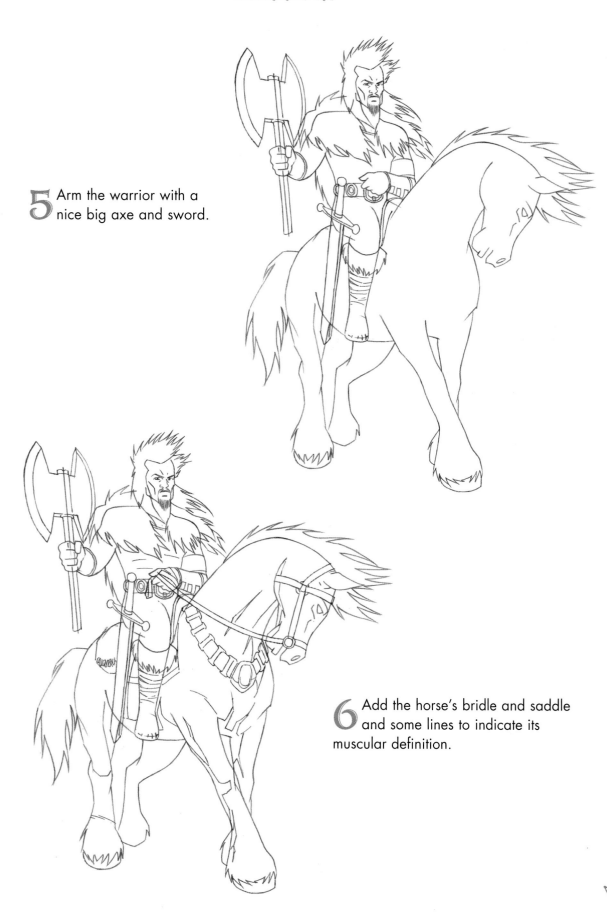

5 Arm the warrior with a nice big axe and sword.

6 Add the horse's bridle and saddle and some lines to indicate its muscular definition.

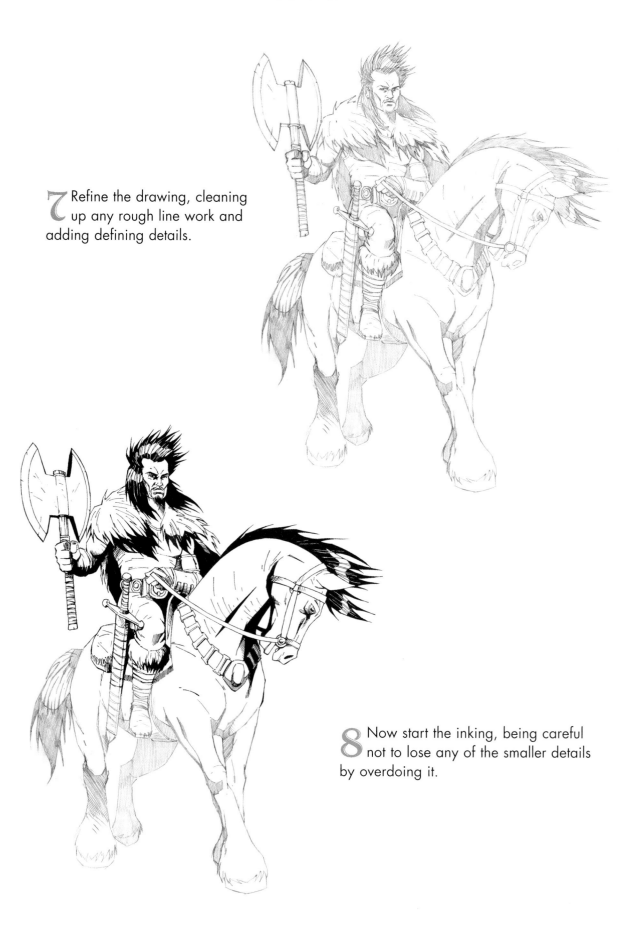

7 Refine the drawing, cleaning up any rough line work and adding defining details.

8 Now start the inking, being careful not to lose any of the smaller details by overdoing it.

9 Note the use of solid black on areas such as the horse's rear legs to create depth, and how the use of solids frame the war-like stance of both warrior and steed.

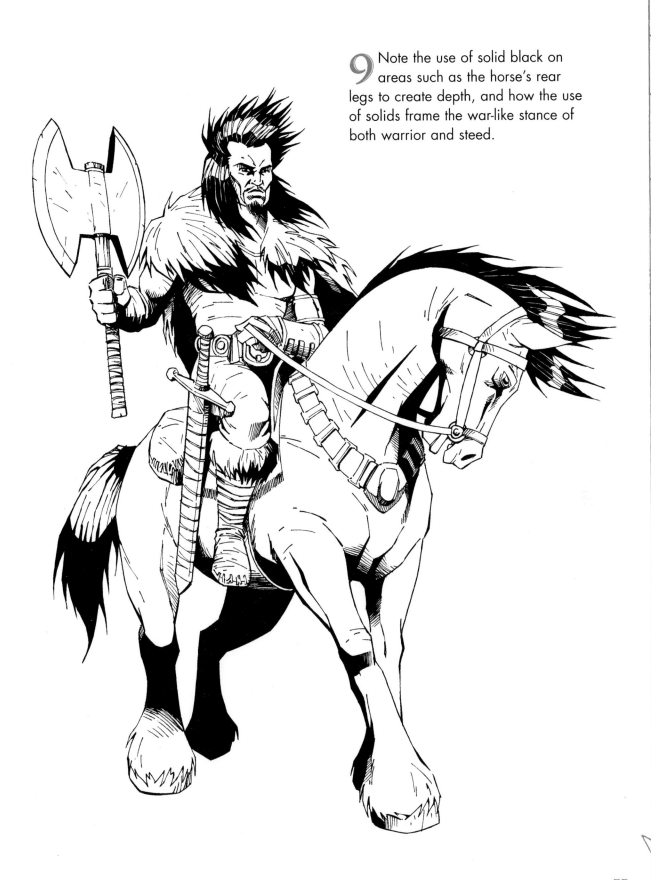

10 Although it may be tempting to colour this warrior in with dark colours, try breaking areas up with browns and yellows instead, so that the image doesn't look too flat.

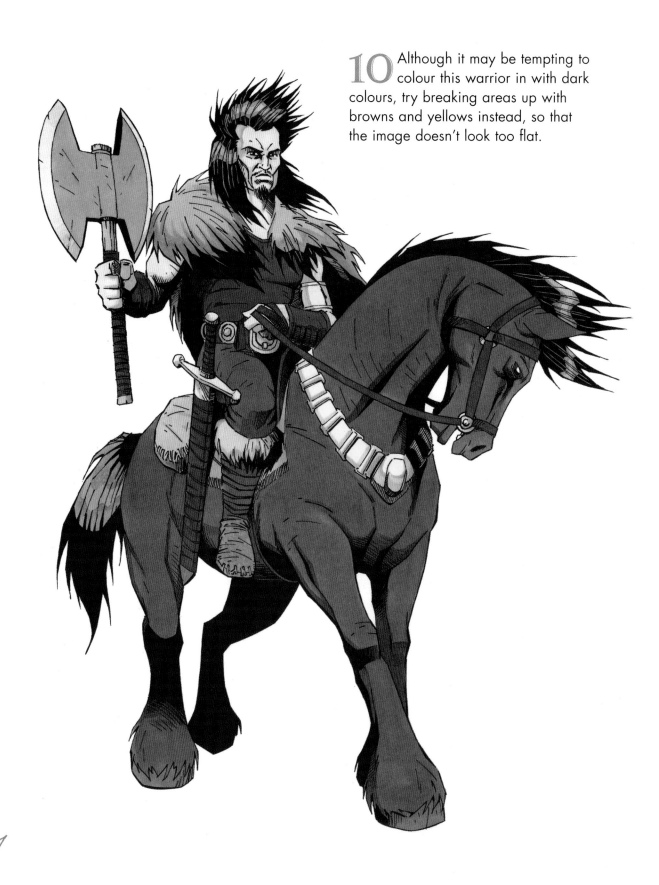

WARRIOR GALLERY

Here are some examples of warriors of all types, doing what they do best – preparing for battle. Using the breakdown stages we've covered in the previous pages, try your hand at reproducing some of these heroes and heroines. Alternatively, use them as inspiration for creating your own characters.

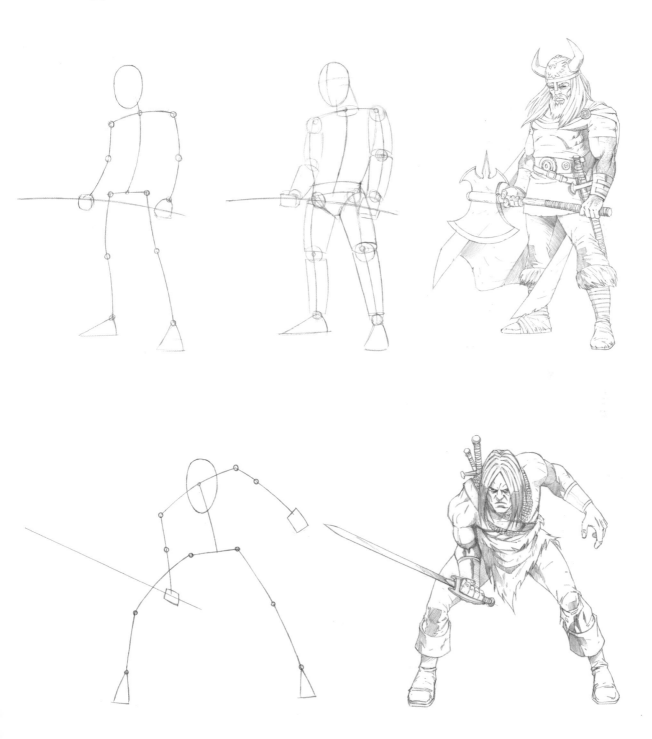

WARRIOR GALLERY CONTINUED

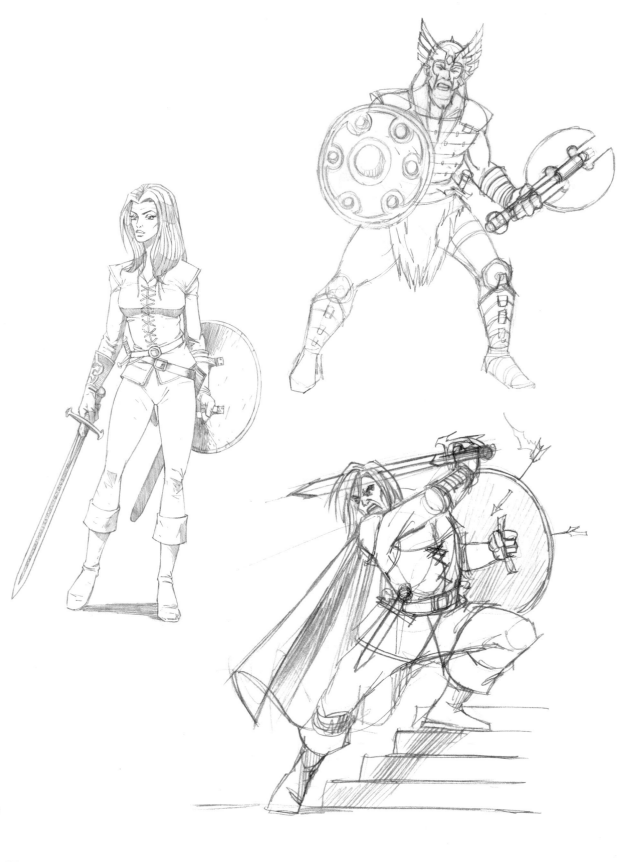

DWARVES

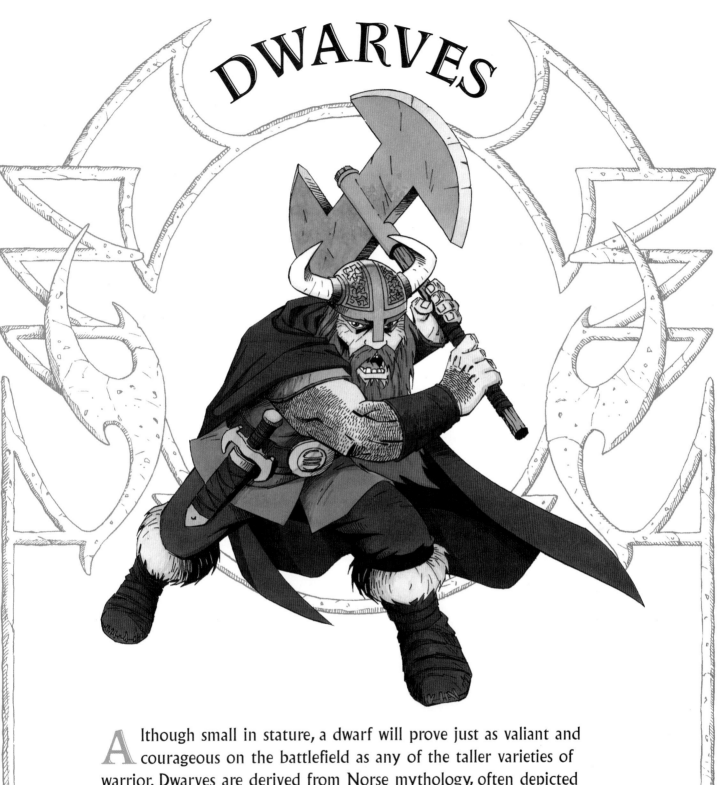

A lthough small in stature, a dwarf will prove just as valiant and
courageous on the battlefield as any of the taller varieties of
warrior. Dwarves are derived from Norse mythology, often depicted
as miniature Vikings, and are sometimes considered distant relatives
of the elves.

DWARF CHARACTER
Note the type of helmet on this example of a dwarf – he's definitely a tiny Viking!

1 Don't forget – this is a dwarf, so the stick man in this instance may, in fact, appear more like a stick child.

2 Now let's add the usual cylinders and squares. Note that these are shorter, bulkier forms than the more lengthy, streamlined versions used to create the average-sized adult form that we've been drawing up to now.

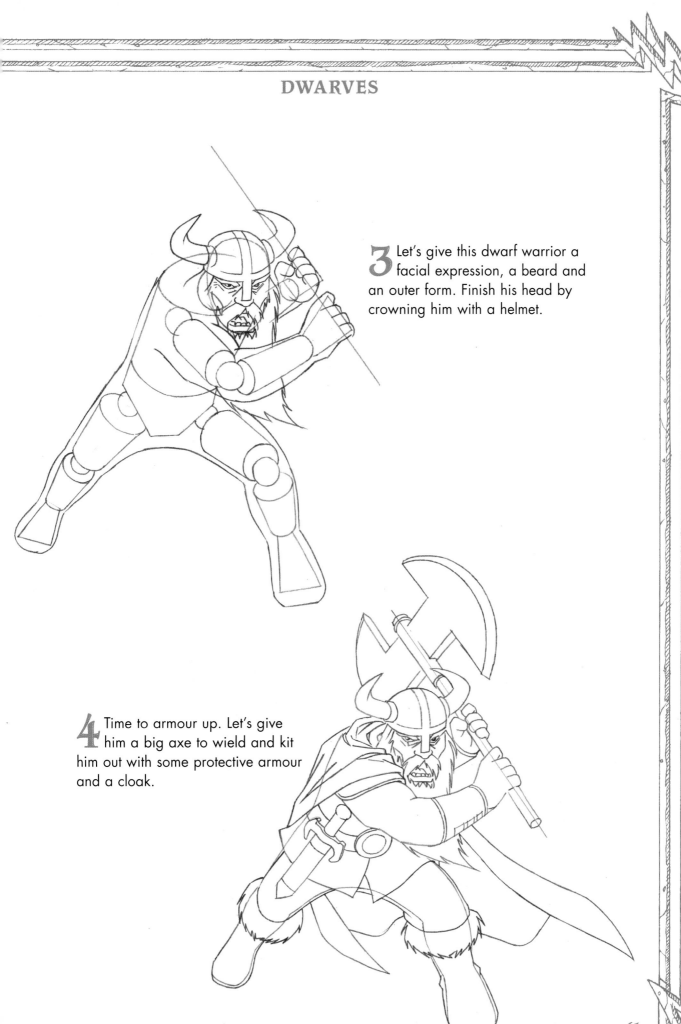

3 Let's give this dwarf warrior a facial expression, a beard and an outer form. Finish his head by crowning him with a helmet.

4 Time to armour up. Let's give him a big axe to wield and kit him out with some protective armour and a cloak.

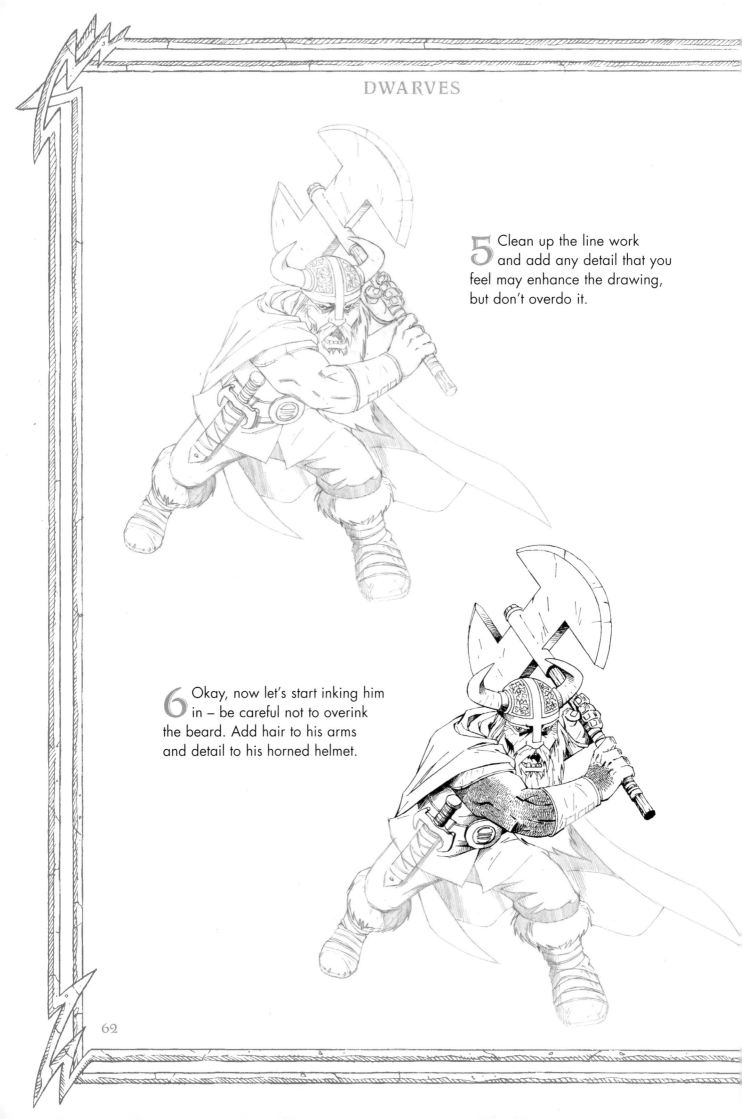

5 Clean up the line work and add any detail that you feel may enhance the drawing, but don't overdo it.

6 Okay, now let's start inking him in – be careful not to overink the beard. Add hair to his arms and detail to his horned helmet.

7 Complete the inking of the dwarf's lower half, taking care with the leather binding of his boots.

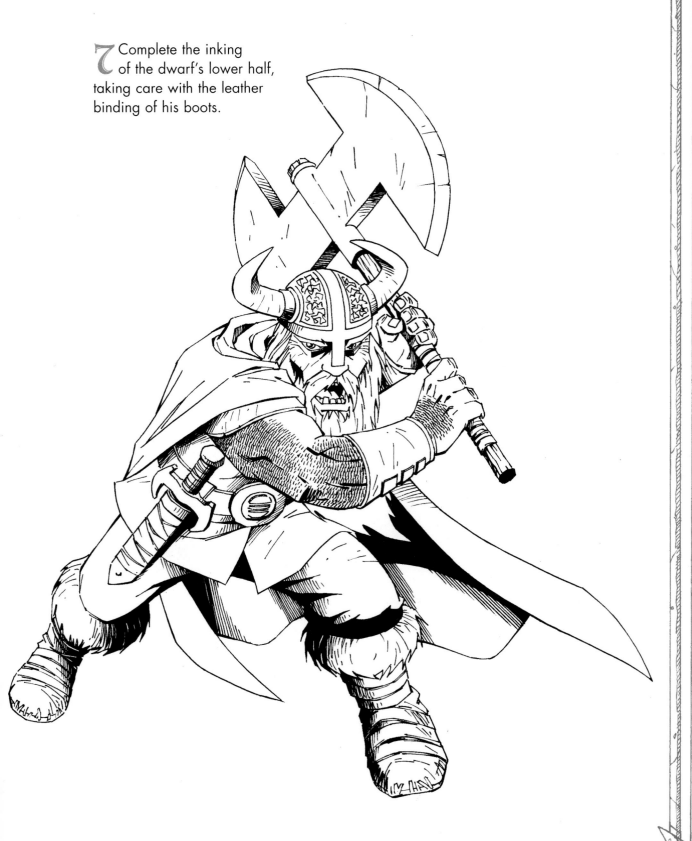

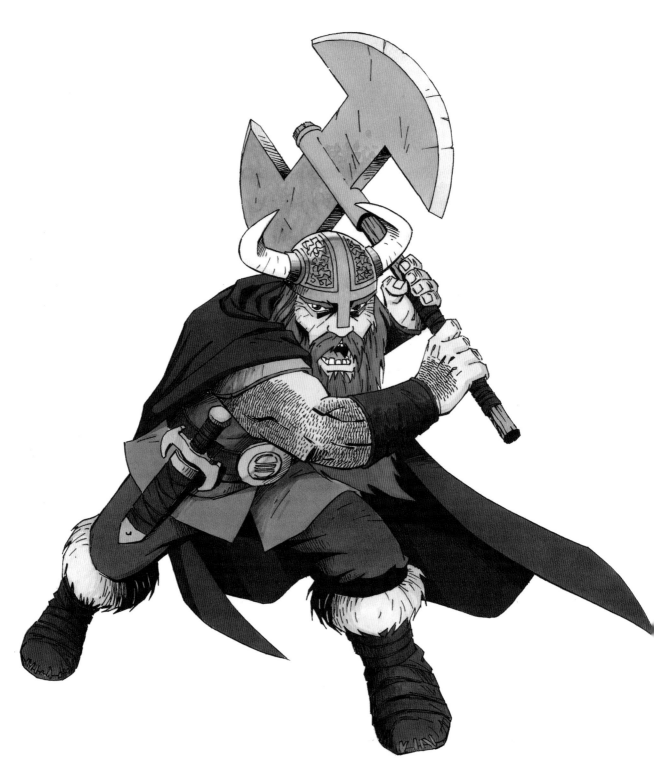

8 And here he is in all his colourful glory! Ginger is always a popular choice for dwarf hair, but experiment with your own ideas. Keeping to masculine colours, such as darker browns and greys, will add strength and weight to your drawing.

ORCS

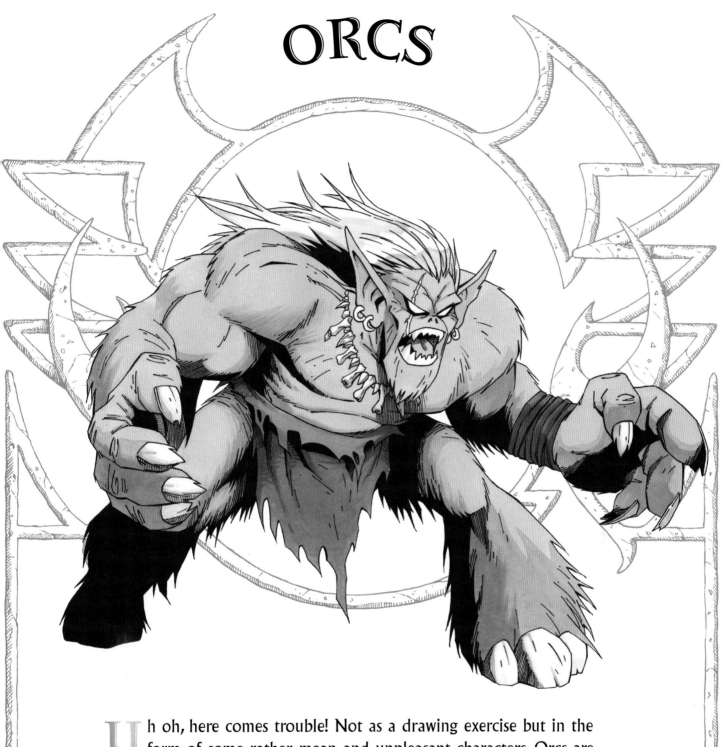

Uh oh, here comes trouble! Not as a drawing exercise but in the form of some rather mean and unpleasant characters. Orcs are evil and repulsive creatures, but they are great fun to draw. So, are you ready to meet them?

ORC 1

No one really knows the true origins of orcs, only that a force of evil created them. This one's a real baddy!

1 Start with the stick figure. Orcs are generally significantly taller than any adult human. Bear this in mind when scaling your figure.

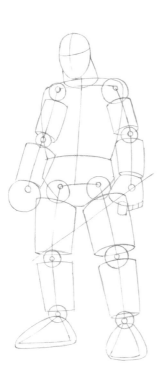

2 Apply the basic shapes. Orcs are far more bulky and muscular than humans, so go for fatter and broader shapes.

3 Give him some facial expression. Remember, this is an orc, he's ugly, so it's okay to go over the top here.

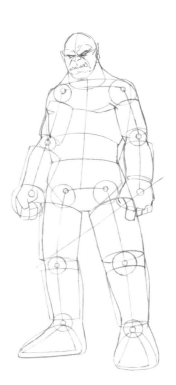

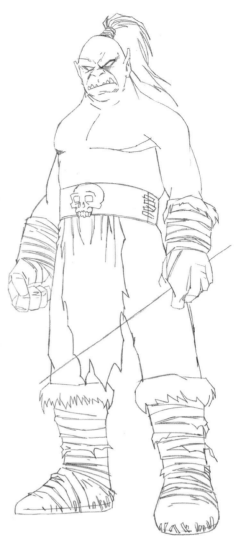

4 Add some form to his body. Note the lack of any neck to speak of. He does have neck bones, of course, otherwise he wouldn't be able to move his head, but the sheer bulk of muscle surrounding his upper body hides any indication of a neck.

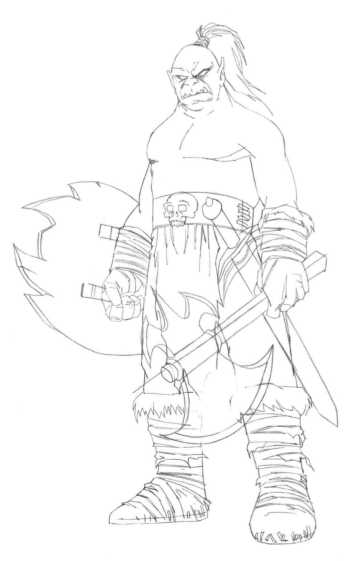

5 Apply some leather chaps, belts and animal skins. Hmm, he may be dressed but he might still feel the chill...

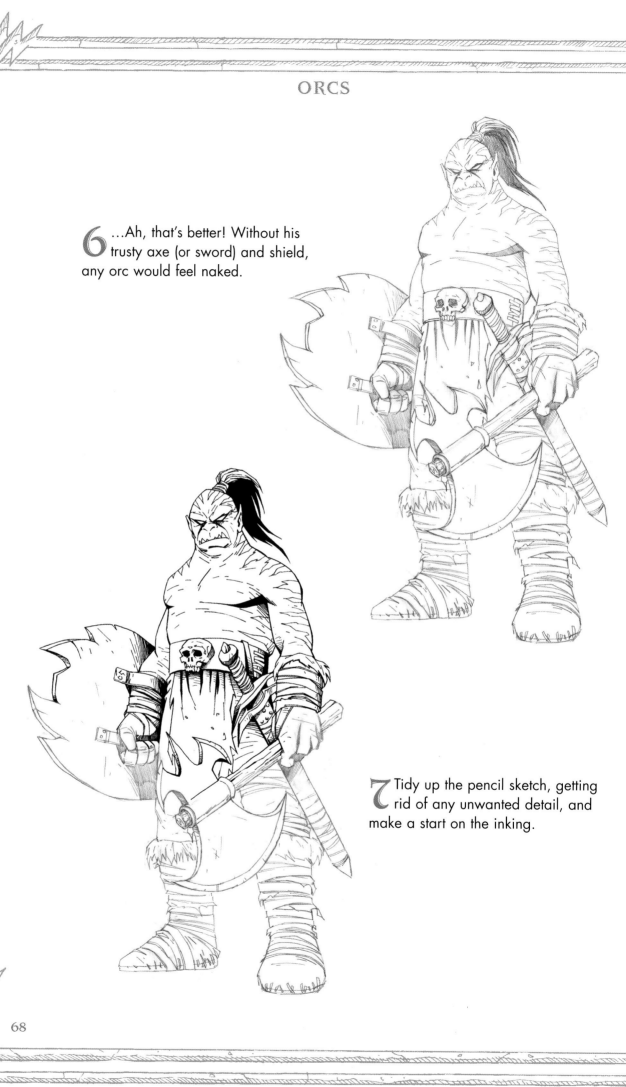

6 ...Ah, that's better! Without his trusty axe (or sword) and shield, any orc would feel naked.

7 Tidy up the pencil sketch, getting rid of any unwanted detail, and make a start on the inking.

8 Try not to overdo it though, or you'll risk spoiling the more detailed areas.

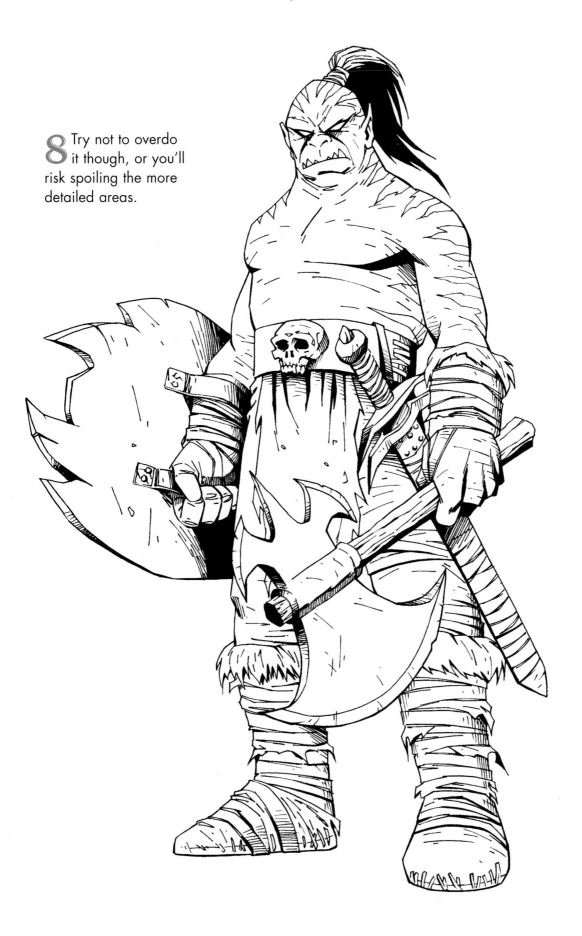

9 Later, we'll look at how best to colour in your drawing using various mediums, but for now here's something to whet your appetite. Orc skin tends to be dull – muddy greys and browns with a green hue. Some orcs are almost black. Stick to muted colours for the armour and weapons, too.

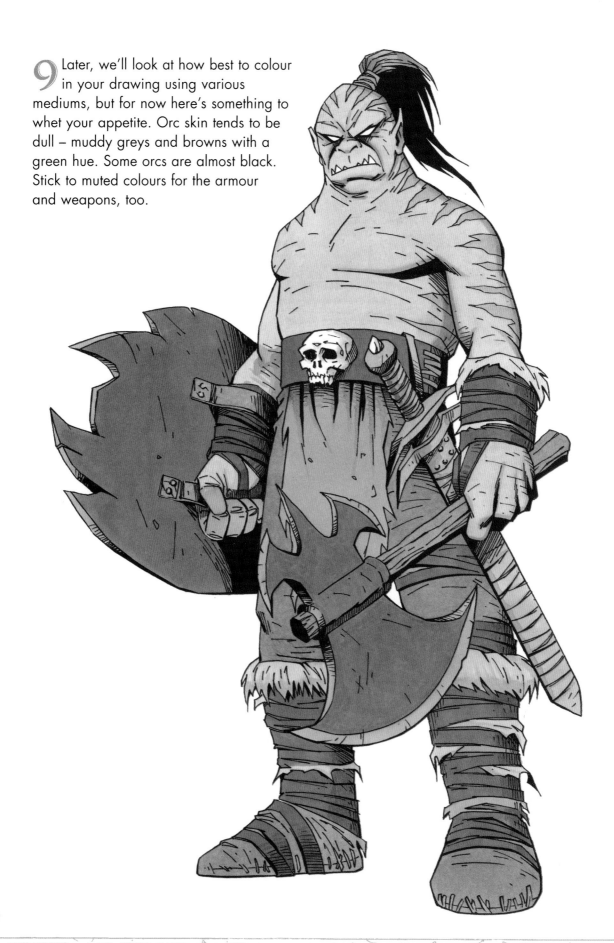

ORC 2 *(goblin type)*

Orcs come in all shapes and sizes, and here we have a smaller goblin version who's just as deadly. It is believed that the variation in types of orc is due to selective breeding. It was thought that some were a combination of elf and pig or wolf. With this character we have a bit of all three; elf (the ears), pig (the face) and wolf (the mane and the legs).

1 Try to think of this stick figure as a human form mixed up with animal. Note that the legs are rather like those of a dog.

2 Add some body shapes to bulk out the goblin's form.

3 The facial features differ considerably from those of the warrior brute on previous pages. He has a thinner face, bigger eyes and larger ears. Note that the eyes are left blank. There is no pupil, which makes the overall facial appearance more sinister.

4 Now apply the outer body form but give the line work the appearance of hair, and give the figure a big shaggy mane, making him look like some sort of demonic punk rocker.

5 Arm him with a club and he's ready for inking.

6 Note that you don't have to draw every strand of hair to make a character look furry. This can sometimes render an illustration too fussy or over-complicated, but by all means add extra lines here and there if you feel it helps.

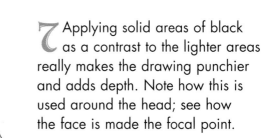

7 Applying solid areas of black as a contrast to the lighter areas really makes the drawing punchier and adds depth. Note how this is used around the head; see how the face is made the focal point.

8 Orcs are generally dull and dirty-looking in colour. Applying these tones helps to create a more sinister appearance. Of course, you can also experiment with your own colour schemes, but remember, anything too light and 'jazzy' may make this character seem less scary.

GIANT ORC 1

Some orcs are nomadic and live in caves. They have little intelligence and survive purely by their brute strength. Because of their size, they spend a lot of their time hunting and eating.

1 Start with a wide slouching, stick-figure frame.

2 Use oversized shapes to create form. Remember, this guy is massive!

3 To reflect this brute's bad disposition, give him narrow eyes that are close together, a small pug nose and big mouth full of fangs.

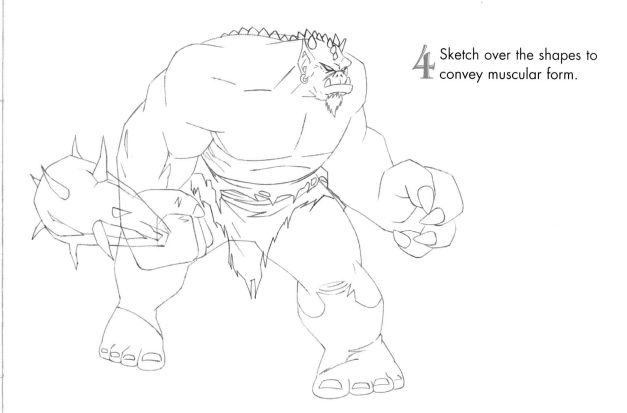

4 Sketch over the shapes to convey muscular form.

5 Add definition to the hands, giving him a nice set of claws, and throw in a hefty club for good measure. Note how at this stage, shading areas around his bulky torso helps to emphasize his body mass. At the inking stage these areas will really help make the image more dynamic. Let's give him some animal skin loincloth for his modesty.

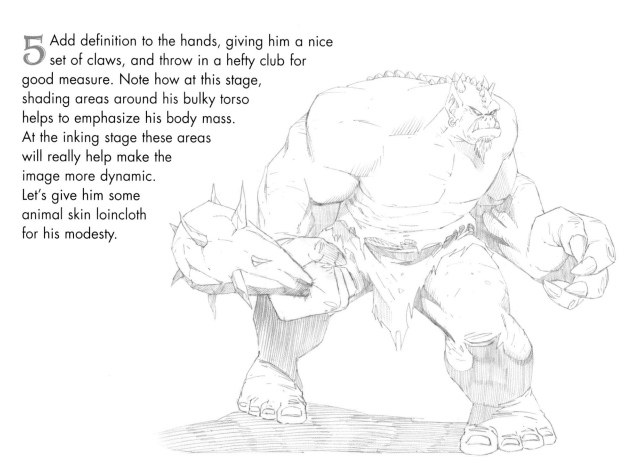

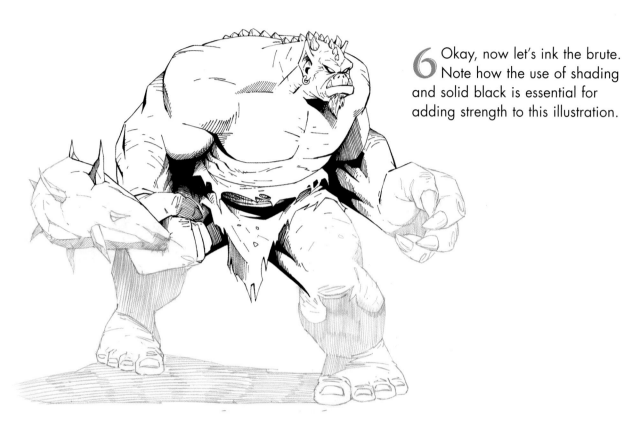

6 Okay, now let's ink the brute. Note how the use of shading and solid black is essential for adding strength to this illustration.

7 Add further shading to the lower legs and the insides of the palms, to express the brutal force of this mean creature.

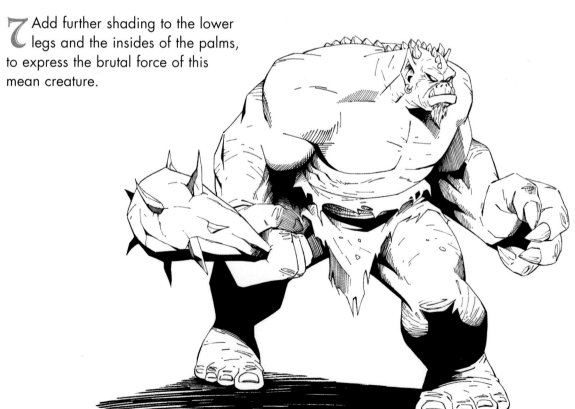

8 No prizes for guessing the colour scheme here. That's right, more blues and greys.

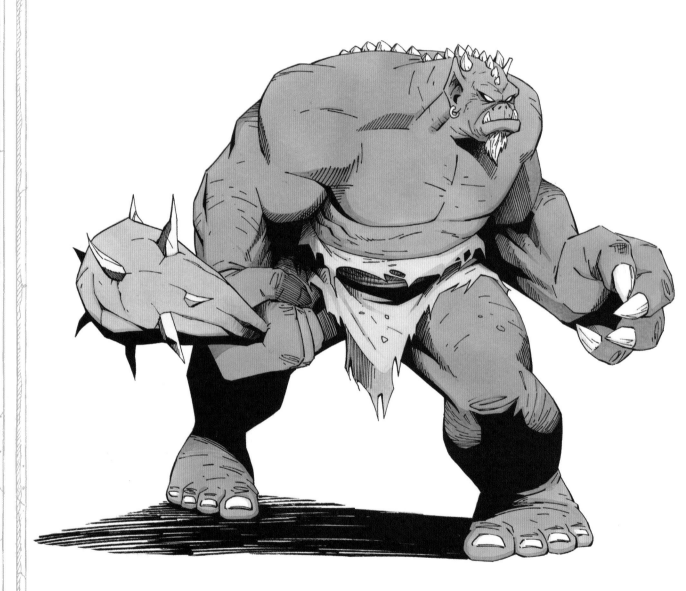

GIANT ORC 2

This orc is not to be messed with – take one look at his necklace of bones! A distant relative of the goblin orc, it also has elements of elf, pig and wolf about it.

1 As with the previous giant orc, the stick figure needs to have a good wide stance.

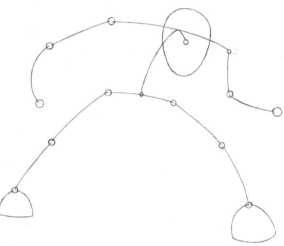

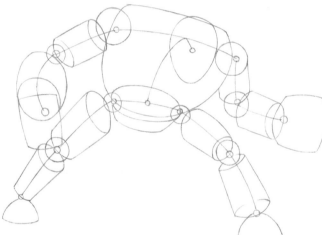

2 Using large bulky shapes, create the body, arms and legs.

3 In contrast to the previous giant orc, this character is going to be extremely hairy.

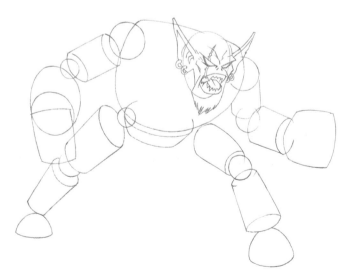

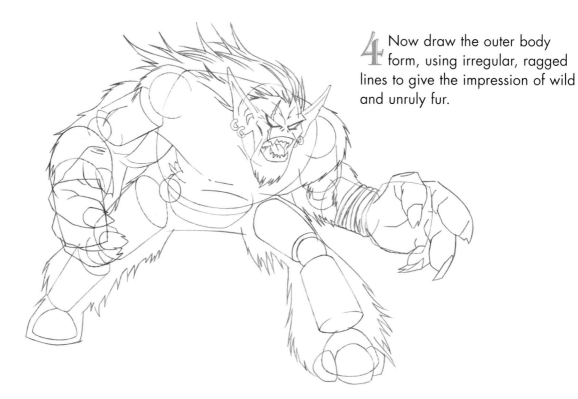

4 Now draw the outer body form, using irregular, ragged lines to give the impression of wild and unruly fur.

5 Apply more detail to the body and hair. Add some animal skin and a necklace of bones (probably made from those of his victims).

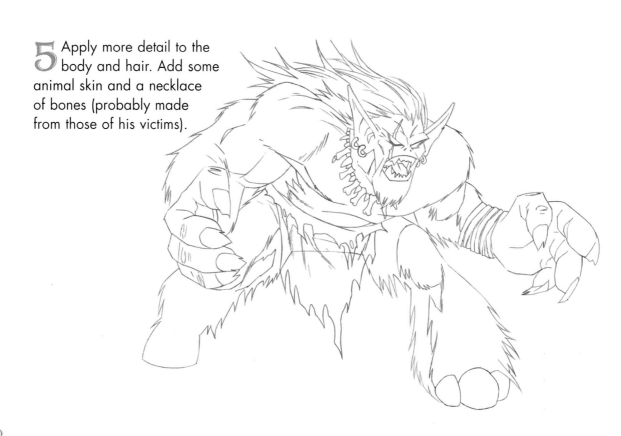

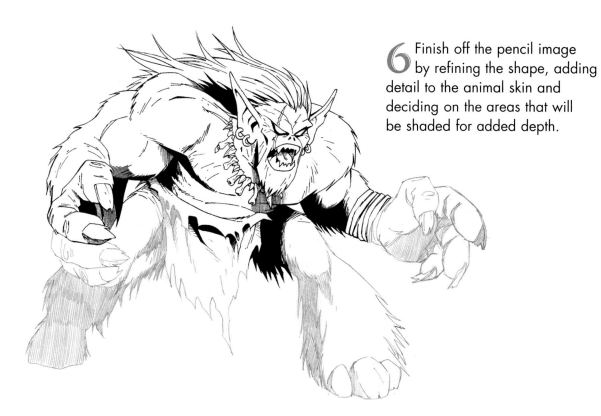

6 Finish off the pencil image by refining the shape, adding detail to the animal skin and deciding on the areas that will be shaded for added depth.

7 Apply the ink and note the use of solid areas in the drawing.

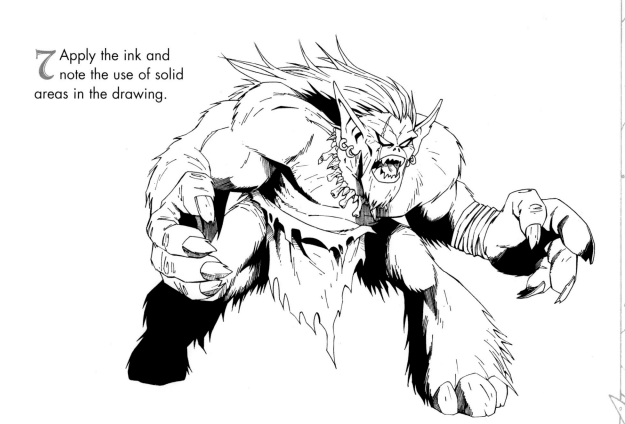

8 As this orc is a hairy beast, brown tones will work well.

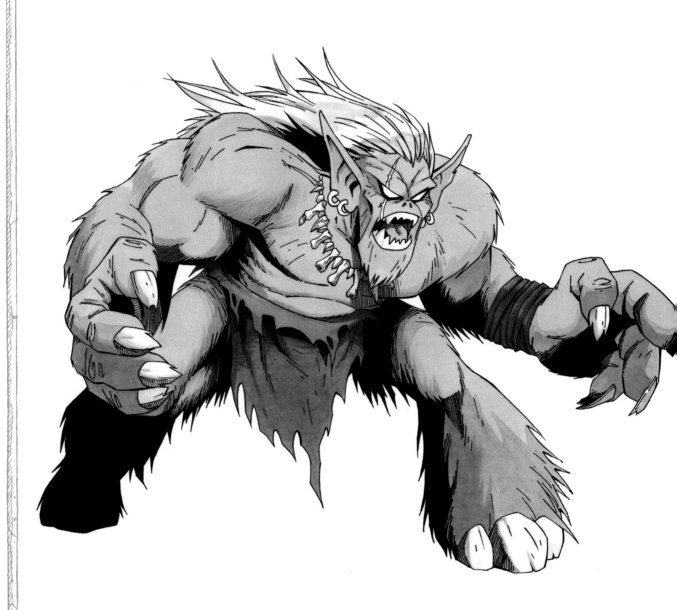

ORC GALLERY

Rather than use up valuable pages taking you through step-by-step stages for every orc variation imaginable, the next couple of pages will display a variety of orcs up to all kinds of mischief. Use these as inspiration to create your own characters.

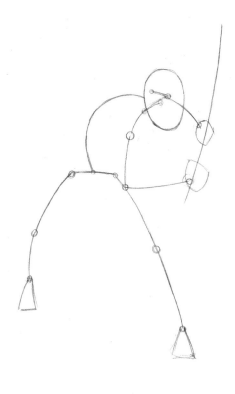

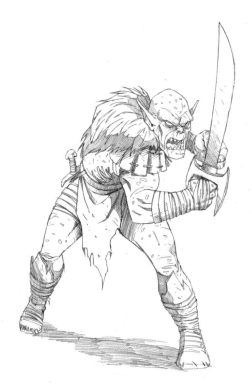

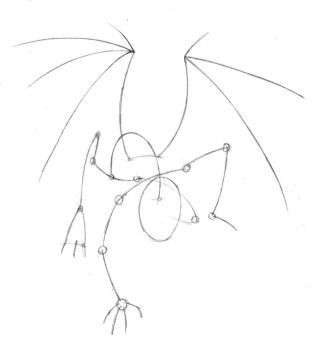

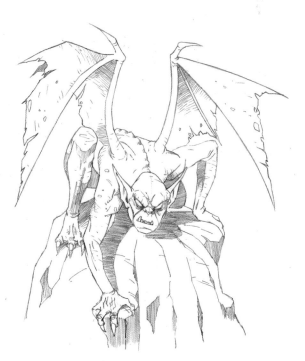

ORC GALLERY CONTINUED

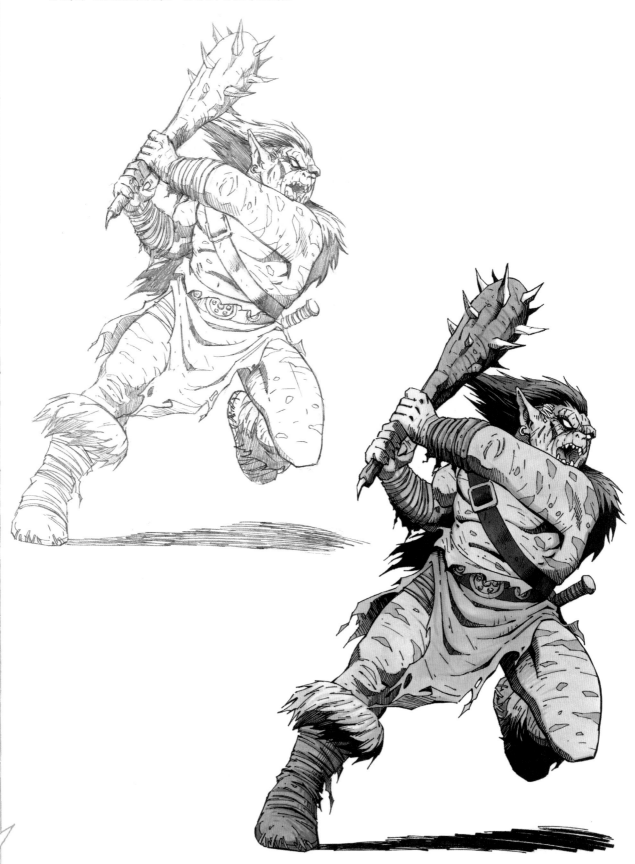

ELVES

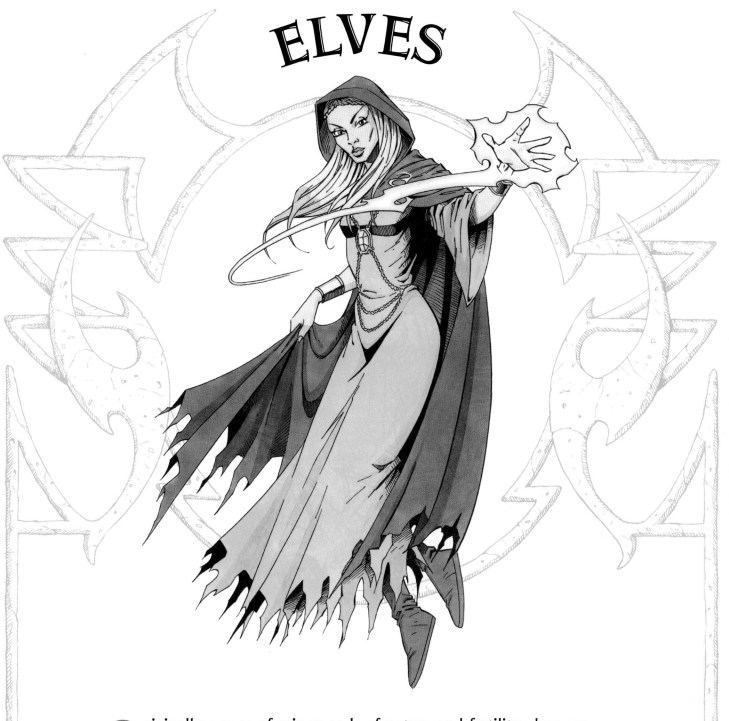

Originally a race of minor gods of nature and fertility, elves are often pictured as youthful men and women of great beauty who live underground or in forests, wells and springs. It is believed that they can live for hundreds of years or that they are in fact immortal. They may look refined and peaceable, but they are also fierce warriors when it comes to defending their kingdom. Some of them also possess magical powers.

FEMALE MYSTIC ELF

This is a classic female elf. She possesses extraordinary beauty, with big expressive eyes, graceful, fragile features, pointed ears and high cheekbones.

1 Like the good witch you met earlier in the book, this elf will be hovering above the ground, so draw her stick frame as if she's floating in space.

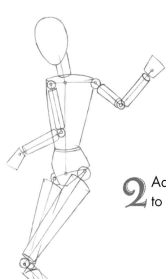

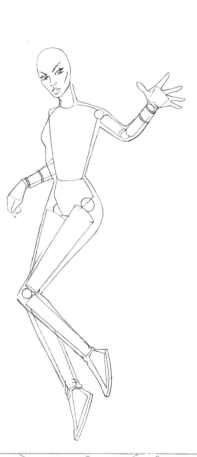

2 Add body shape to the stick figure.

3 When drawing an elf (especially a female elf) care must be taken to give them beautiful, refined features.

4 Let's add some clothing. Go for delicate designs – nothing too armoured or combat-orientated. Elves are generally considered peaceful and earth-loving creatures, so try to reflect this in their overall appearance.

5 As this particular elf has magical powers, let's show this by drawing a mystical glow coming from her hand.

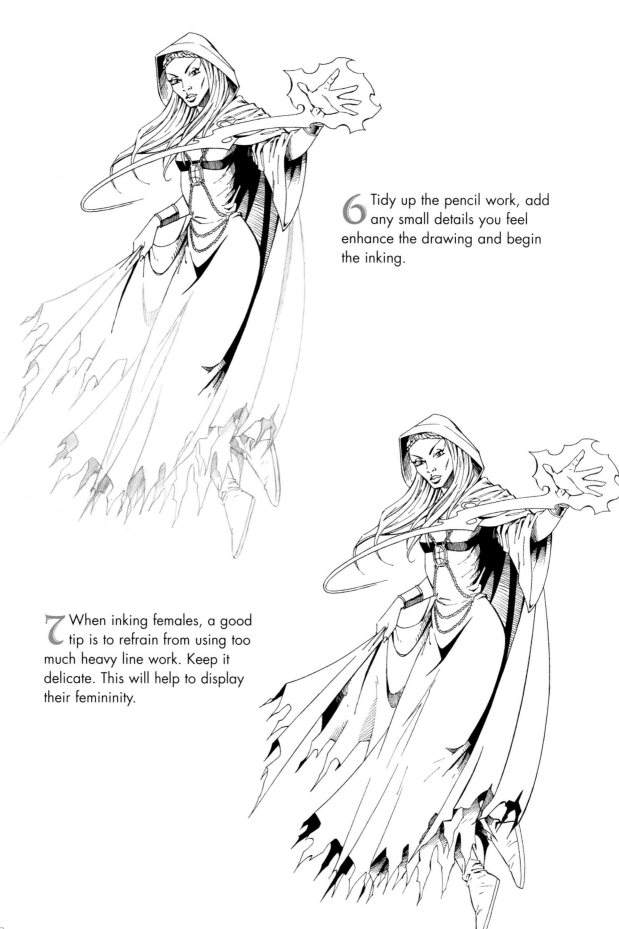

6 Tidy up the pencil work, add any small details you feel enhance the drawing and begin the inking.

7 When inking females, a good tip is to refrain from using too much heavy line work. Keep it delicate. This will help to display their femininity.

8 When applying colour, remember that elves are generally woodland dwellers so pick a colour scheme that reflects this. Greens and yellows are a good choice.

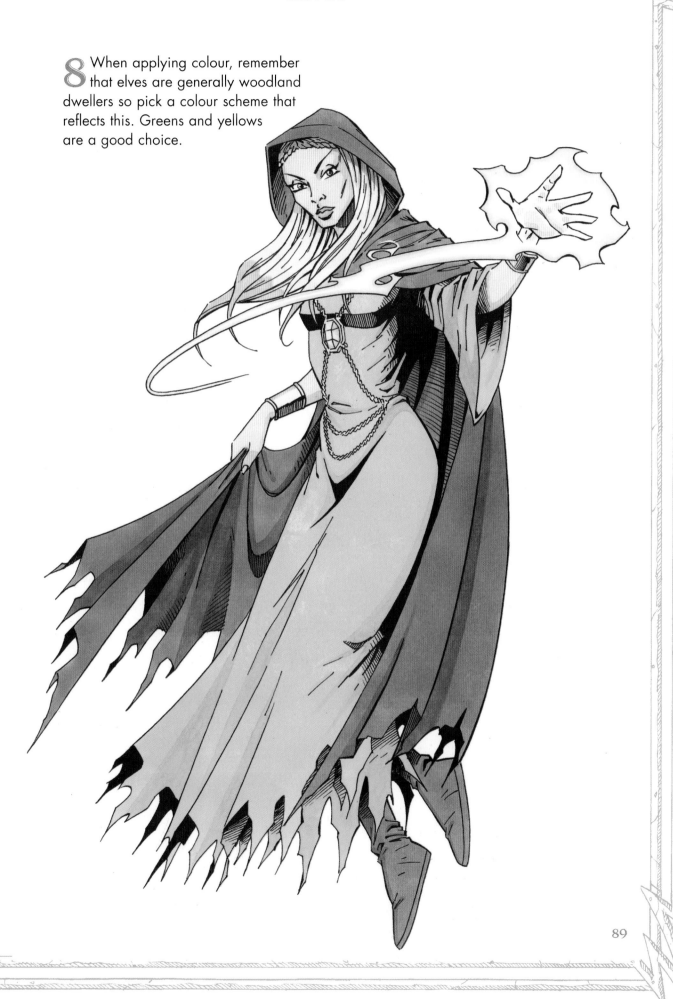

MALE ARCHER ELF

Elves are generally smaller than adult humans and it's often difficult to distinguish between male and female elves at first glance so, when producing drawings of them, you may find yourself using the same shapes and forms. Note that male elves don't have any beard growth.

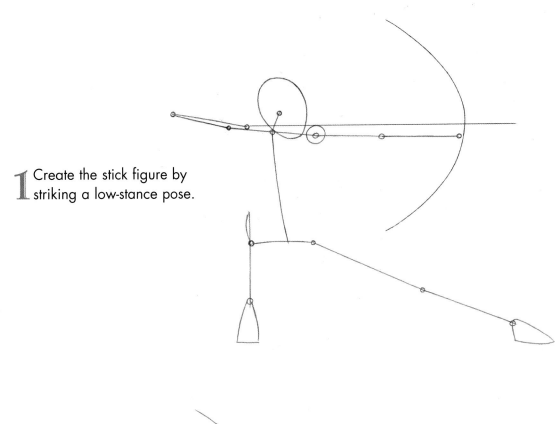

1 Create the stick figure by striking a low-stance pose.

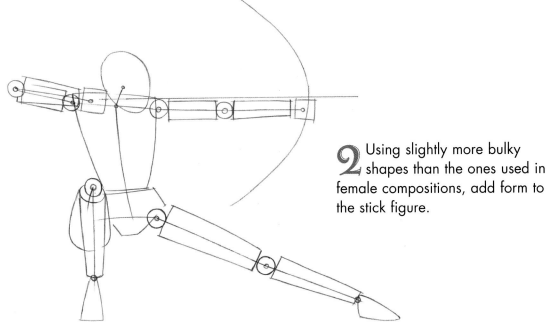

2 Using slightly more bulky shapes than the ones used in female compositions, add form to the stick figure.

3 Now add refined, delicate features to the face.

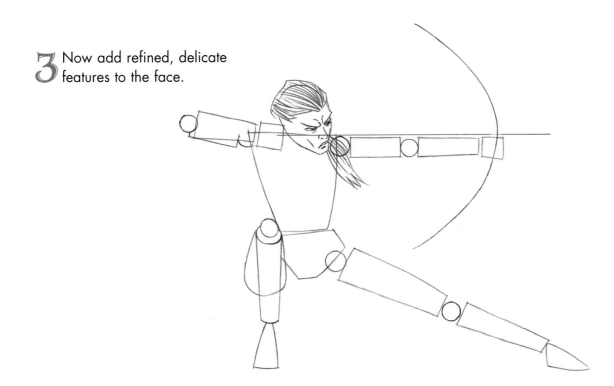

4 Next, apply add the outer body shape.

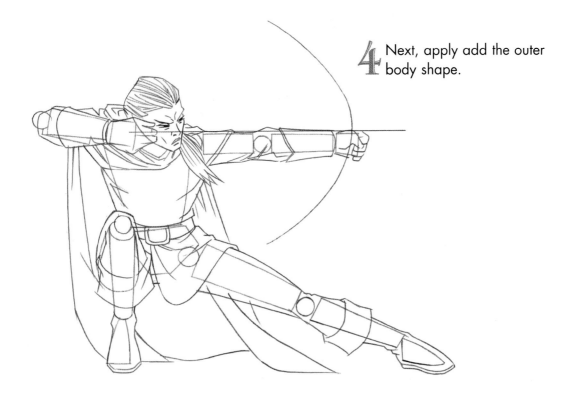

5 Dress the elf in fine garments, with a hooded cape to give him a forest dweller/archer look.

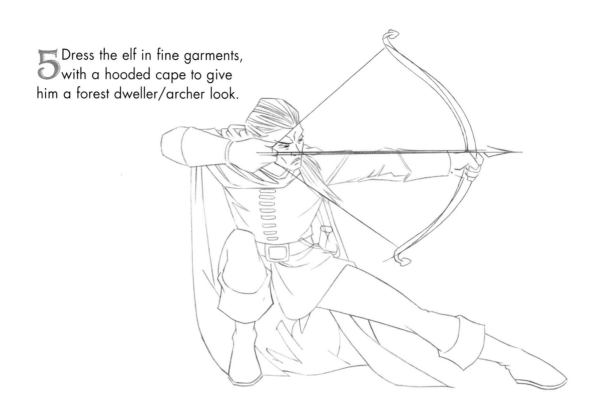

6 Refine your pencil work and add any last touches that you feel are necessary. Note that his weapons are also drawn in a refined way, in keeping with his overall elfin appearance.

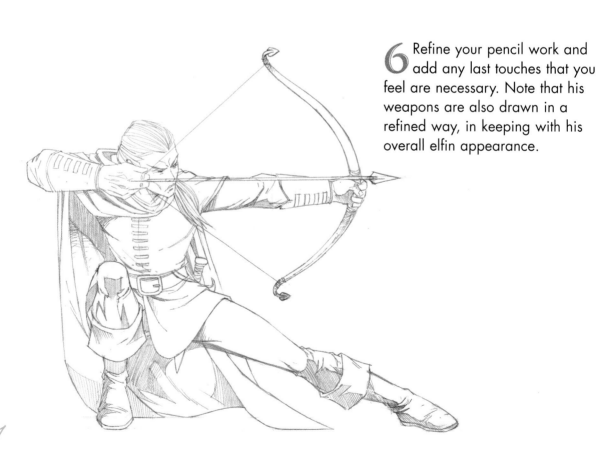

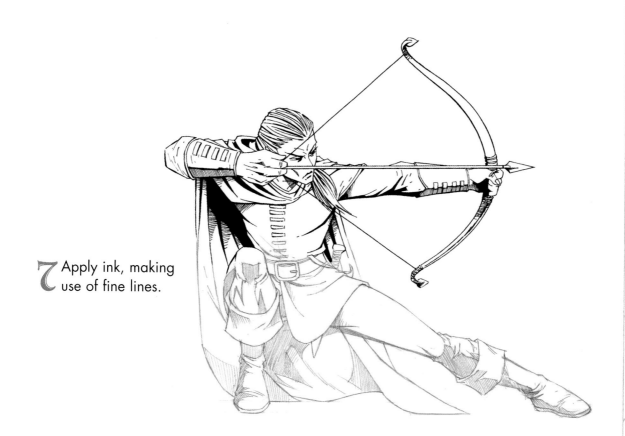

7 Apply ink, making use of fine lines.

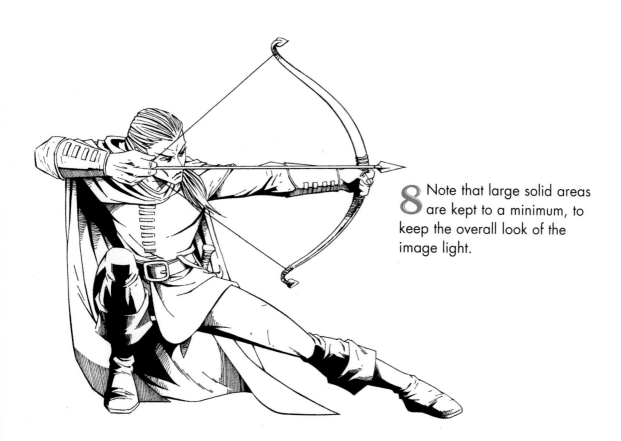

8 Note that large solid areas are kept to a minimum, to keep the overall look of the image light.

9 Again, greens are the obvious choice but perhaps go for dark olive and emerald tones with splashes of brown thrown in, as this is a male elf.

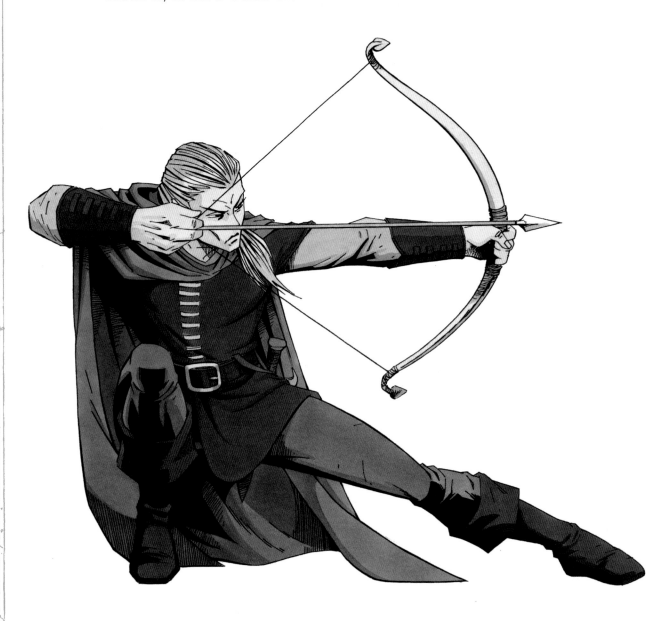

KINGS

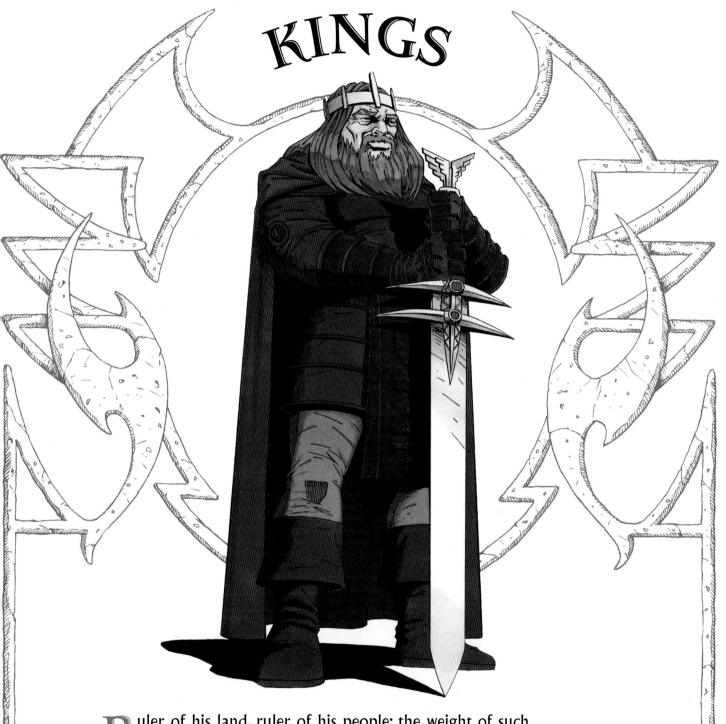

Ruler of his land, ruler of his people: the weight of such responsibility could only be carried on the shoulders of a great man. In the days when kingdoms regularly waged war on each other, a king's people needed to feel safe and secure in the knowledge that their ruler was brave of heart and fierce of sword, feared by his enemies but loved by his subjects: a big man with a big heart. Unfortunately, power can also corrupt a man's heart and mind, creating evil rulers who have been seduced by the dark side.

GOOD KING

This pose suggests that although this king is mighty, he does not use his power irresponsibly. He is the type of king who'll always assess a situation, considering all possibilities, before raising his heavy sword.

1 Using the stick figure, construct a solid, regal pose.

2 When applying basic shapes, remember that this is a big man.

3 Flesh out the form and give the king a face with strength of character. Add a bushy beard to complete it.

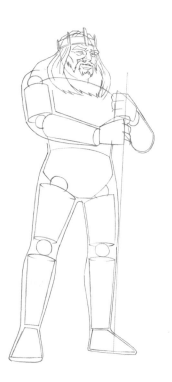

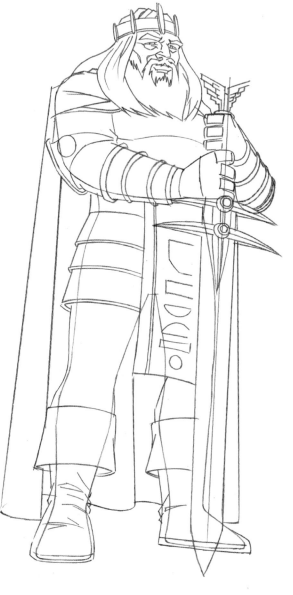

4 Although he is a king, we're not going to dress him up in rich, fancy clothing. His garments will be of the finest material but they will also be functional enough for battle. Give him heavy-duty leather breastplates, gloves, boots and a hefty broadsword. Finish with a regal cloak around his shoulders.

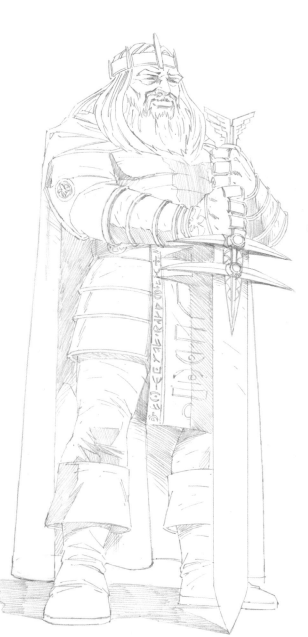

5 Refine the detail in his hair and armour and add some shading to give definition to his overall form.

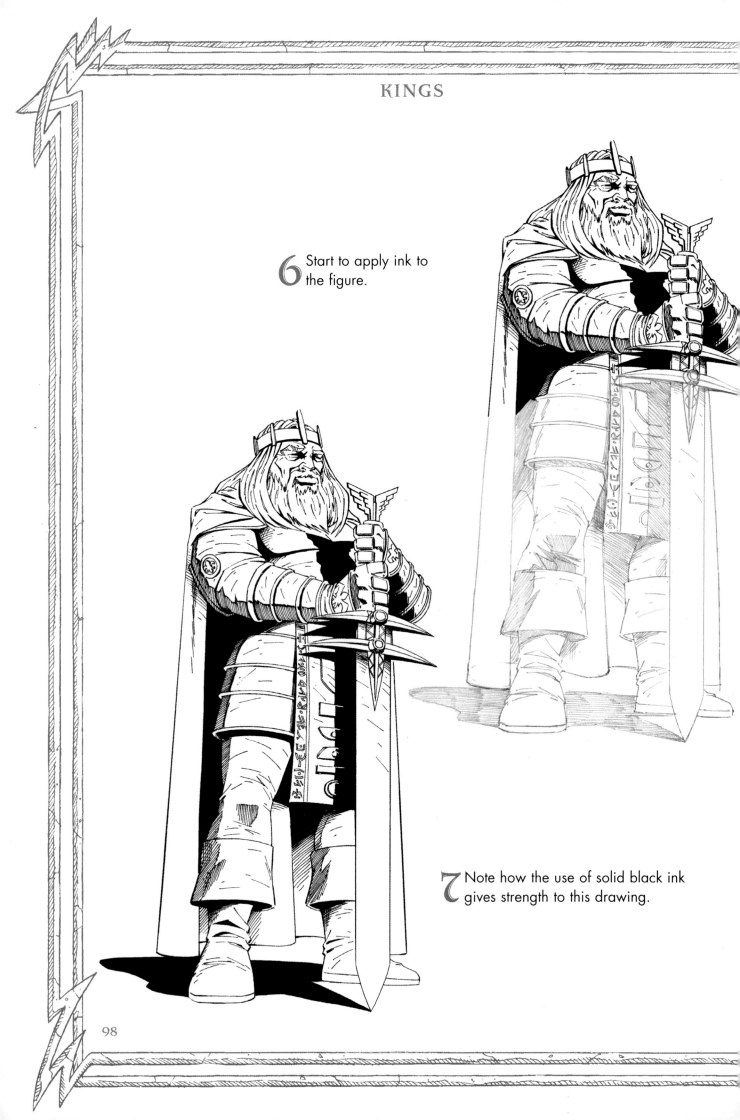

6 Start to apply ink to the figure.

7 Note how the use of solid black ink gives strength to this drawing.

8 Colour the drawing in rich, warm browns and reds.

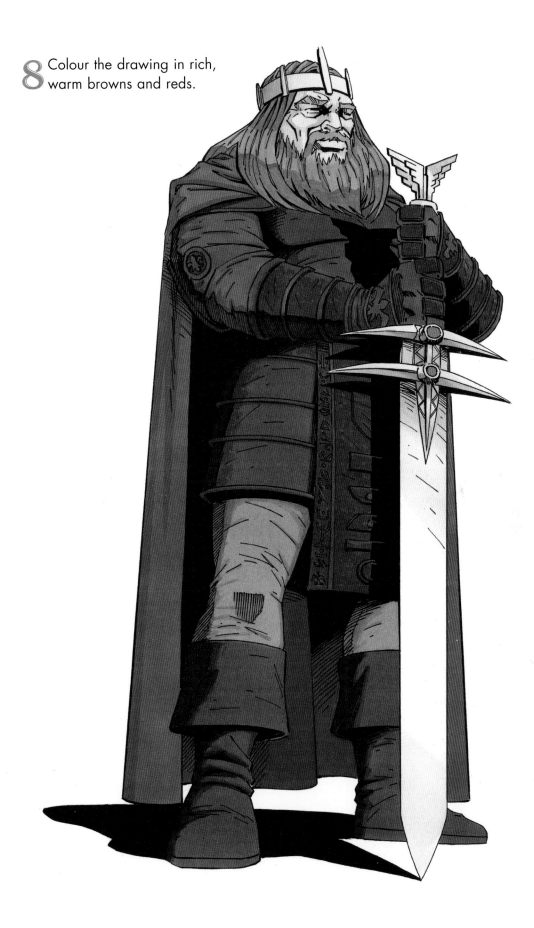

99

EVIL KING

This king (probably crowned by foul means) only craves power and riches. He is never satisfied and will not rest until he controls everything he desires. No brave heart here, just a black one, twisted and cruel.

1 We're going to draw him slumped and brooding on his throne, so we'll need to show this in the basic shape of the stick figure.

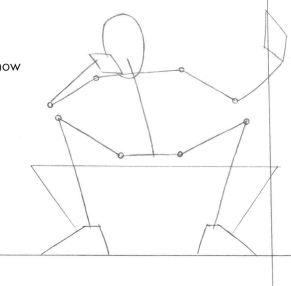

2 Now apply the basic shapes to construct his form.

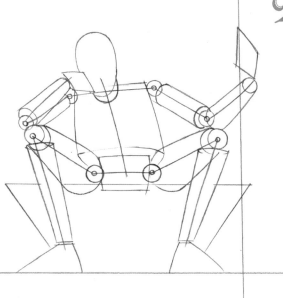

3 Smooth out the body form and draw in his scowling face. Add hair and a crown.

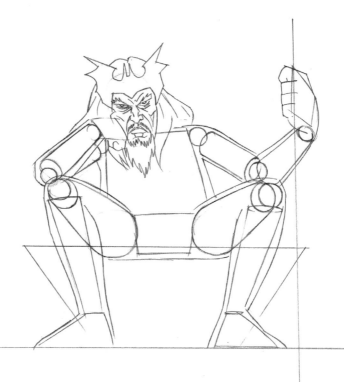

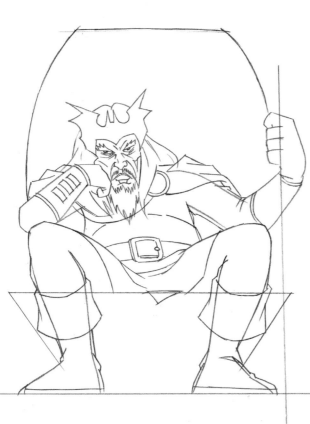

4 Give him clothes, including boots, gloves and a belt. Start shaping his throne at this stage. This will later be developed into the back support of the seat.

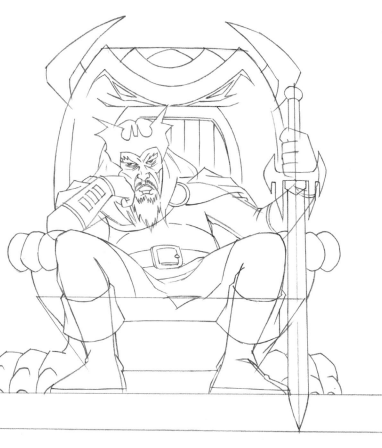

5 This throne resembles a kind of devil or demon – the sort of throne that befits an evil king. Give him a sword in his hand, making him look as if he is about to use it on a displeasing servant.

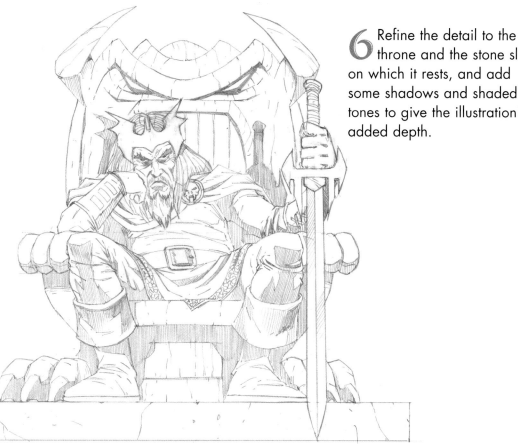

6 Refine the detail to the throne and the stone slab on which it rests, and add some shadows and shaded tones to give the illustration added depth.

7 Start to ink in the drawing.

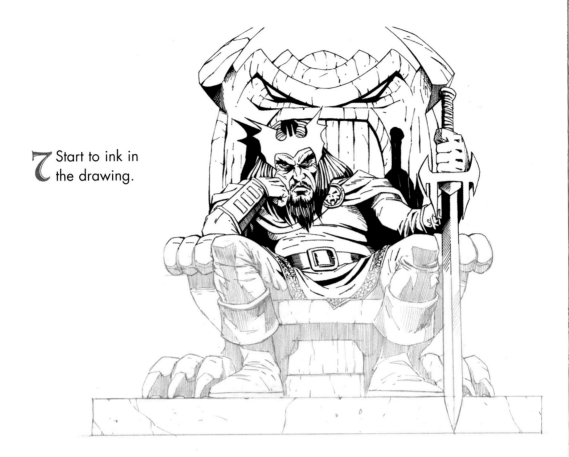

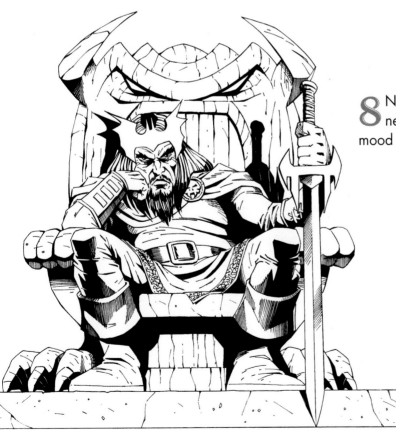

8 Note that the use of solids is necessary in creating the mood and tone of this image.

9 Since this character is consumed by evil, it may suit him to be draped in black. Although a black throne would look cool, it wouldn't help to display the king very well so, by way of contrast, we'll show the throne as a heavy timber construction.

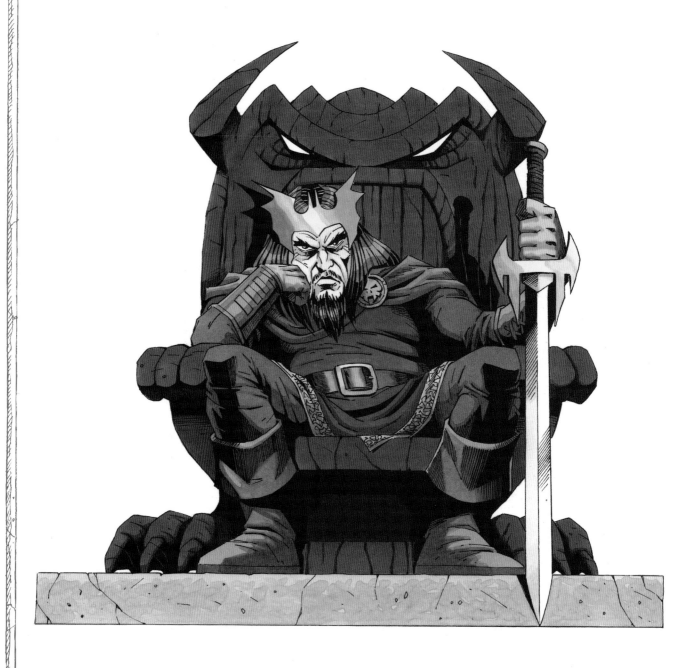

QUEENS

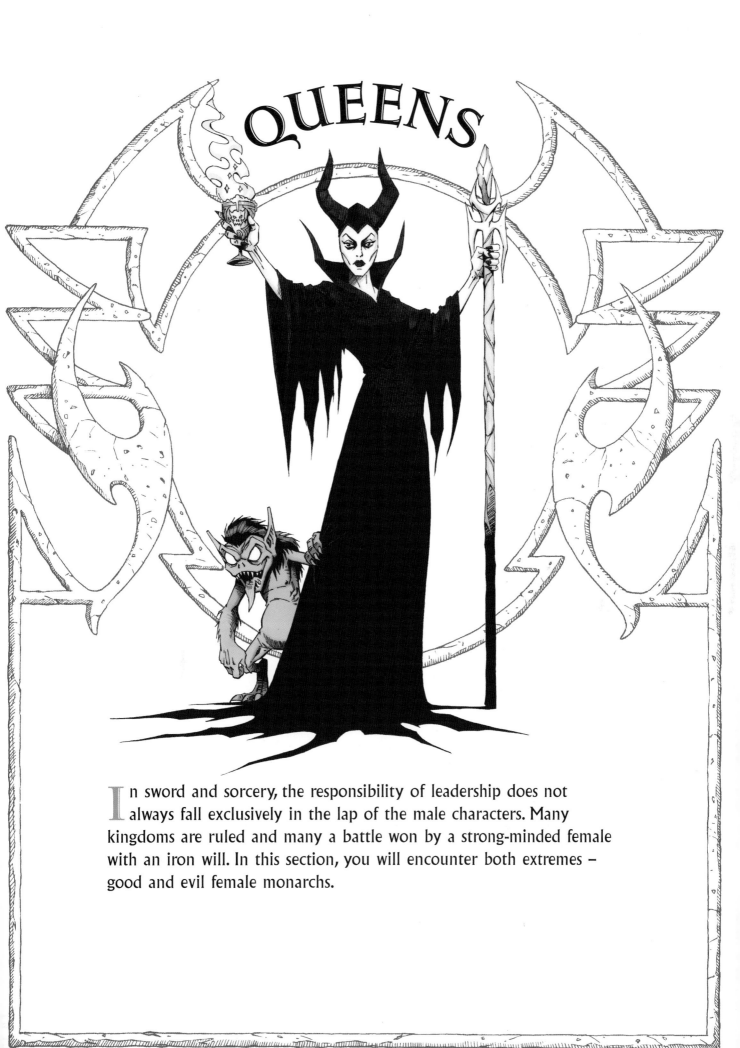

In sword and sorcery, the responsibility of leadership does not always fall exclusively in the lap of the male characters. Many kingdoms are ruled and many a battle won by a strong-minded female with an iron will. In this section, you will encounter both extremes – good and evil female monarchs.

GOOD QUEEN

Although this queen seems a young woman, she has a wise head on her shoulders, and rules with kindness and fairness. A fantasy character's looks don't always tell the whole story – often those who appear mere youngsters are actually old beyond their years.

1 We're going to give this character poise and elegance, so the stick figure needs to be less dynamic than previous examples.

2 Apply the body, keeping to a slender shape.

3 Add refined and elegant facial features and a suitable crown.

4 Give her clothing and a sword. It's always useful to study history books that contain pictures of medieval rulers to get ideas for costumes. You don't have to copy them directly, but it gives you a good starting point for creating your own outfits.

5 Include more defining detail on the figure's costume. Add delicate embroidery to the bodice and folds to the gown. Note that the decoration on this sword distinguishes it from an everyday battle weapon.

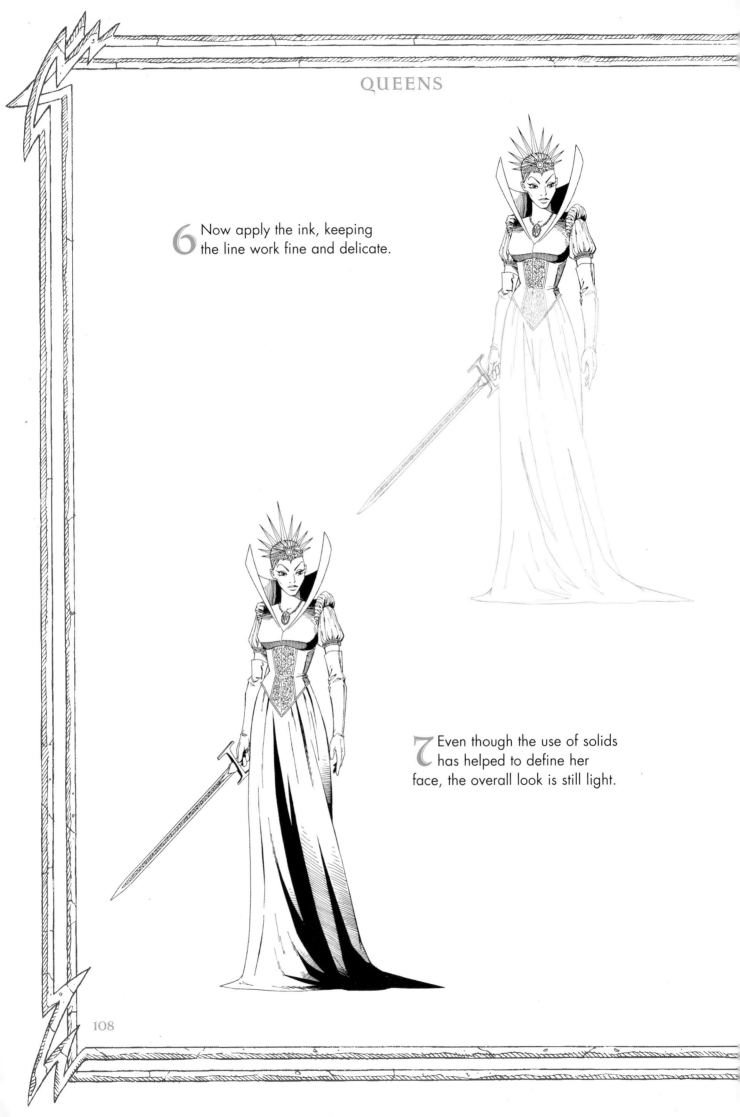

6 Now apply the ink, keeping the line work fine and delicate.

7 Even though the use of solids has helped to define her face, the overall look is still light.

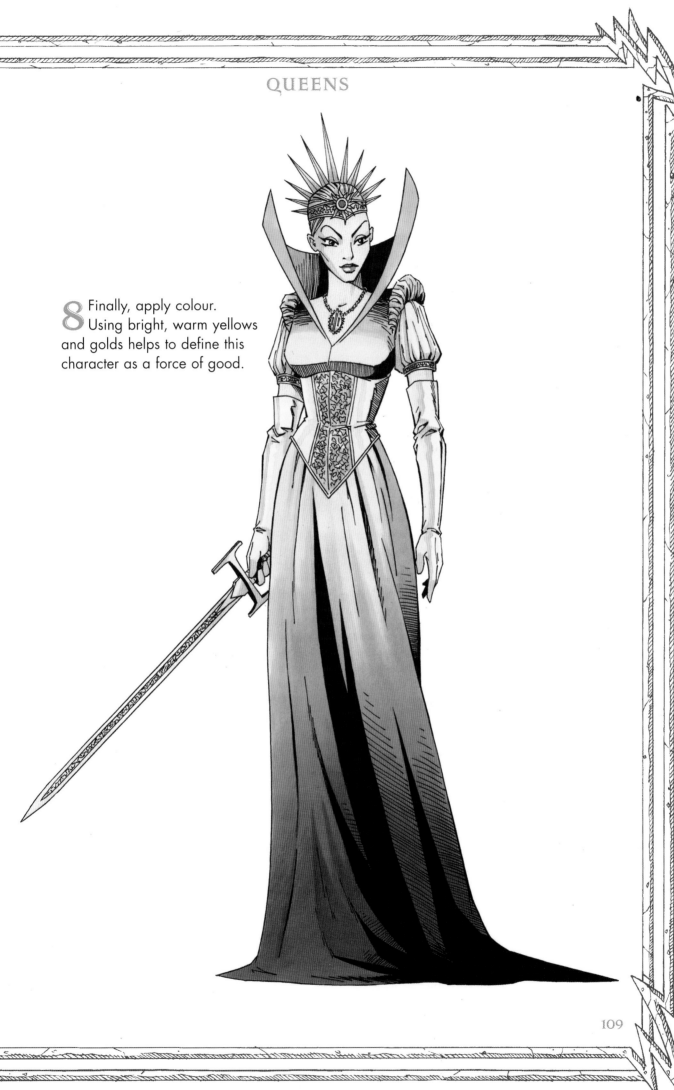

8 Finally, apply colour. Using bright, warm yellows and golds helps to define this character as a force of good.

EVIL QUEEN

This queen's looks also reflect her personality. She's a ruthless opponent who will stop at nothing in her quest for power over everybody and everything, using every trick in the book to get what she desires.

1 As this image will be used to convey a tyrannical nature, we can use a more dymanic pose for the stick figure. We are also going add a little demonic sidekick at her feet.

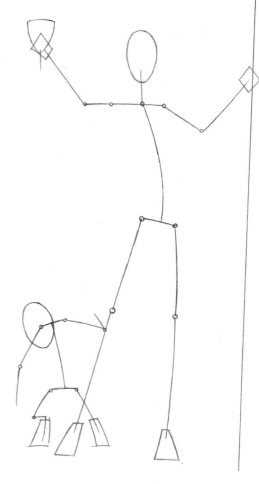

2 Use long lines for the basic shape of the queen and short ones to create a stunted frame for her little helper.

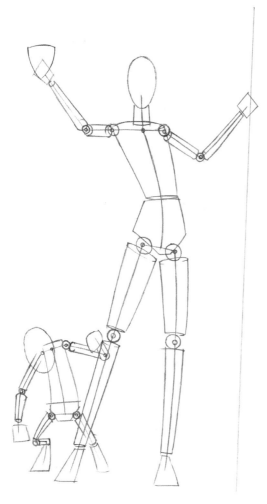

EVIL QUEEN

3 Although the facial features are attractive, they also have a certain haughtiness, to convey cruelty. Have as much fun as you like creating an ugly face for her pet. At this stage, we can add the outer body form.

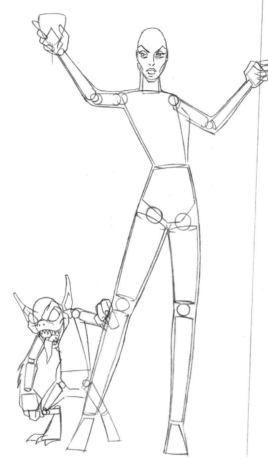

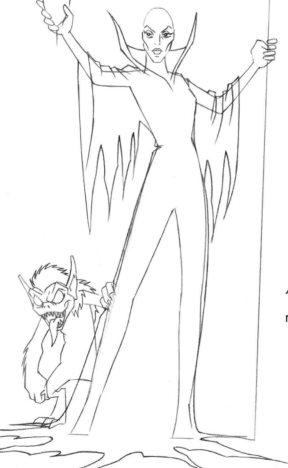

4 Note how her costume gives her the appearance of a demon or night creature.

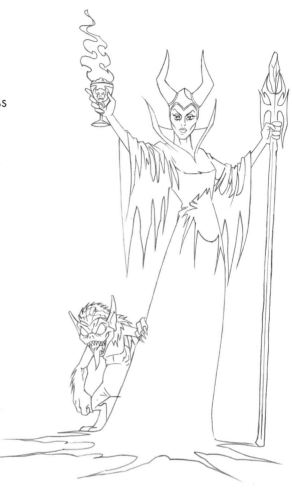

5 Note how the horned headdress further enforces a visual sense of evil. Give more substance to her mystical staff, complete with crystal, and her magic goblet.

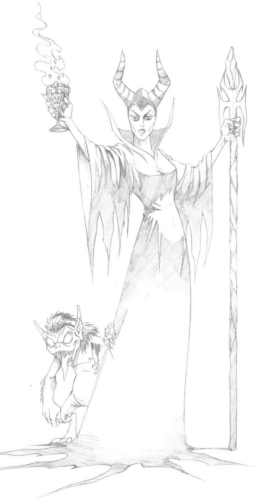

6 Add refining detail to finish off the pencil sketch. Here is where we establish that most of her costume will be solid black, a device used to great effect in the inking stage.

7 Now begin to apply the ink. Create shading by drawing closely spaced parallel lines, called crosshatching.

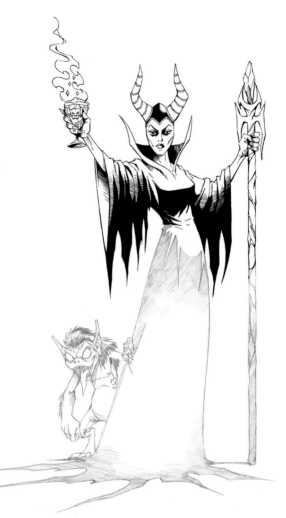

8 Note that although there is very little detail either in the costume or, in fact, the whole drawing in comparison to previous ones. Thanks to the simple use of solid black, the image loses none of its impact.

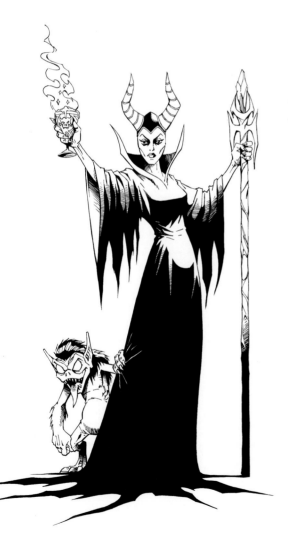

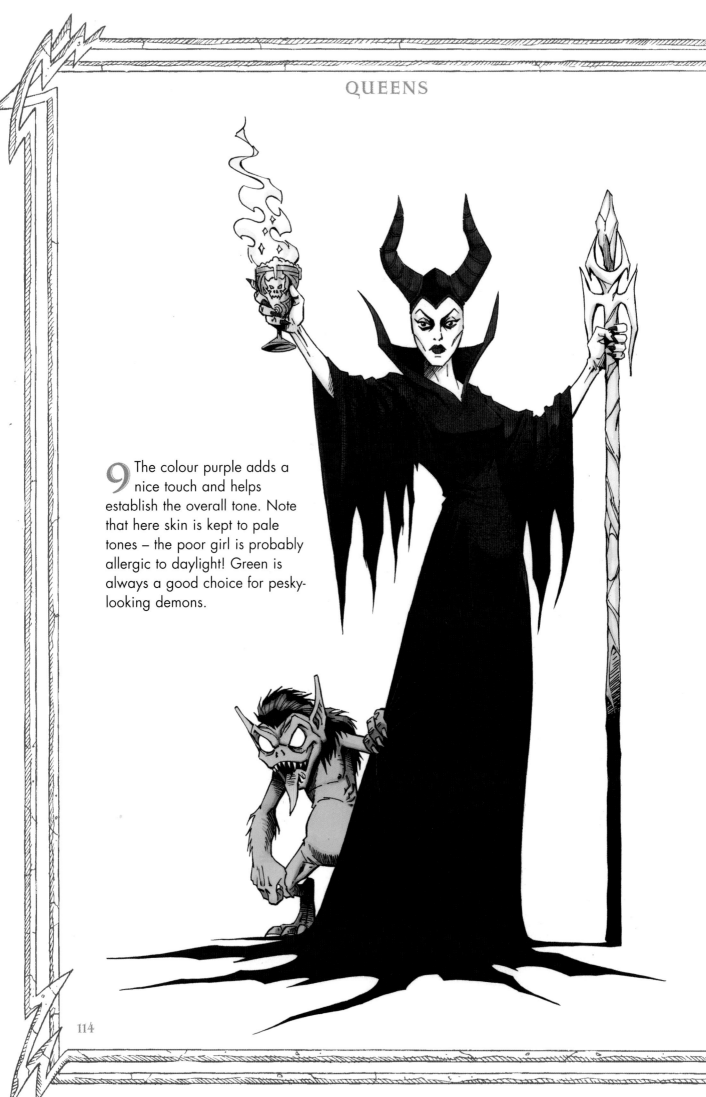

9 The colour purple adds a nice touch and helps establish the overall tone. Note that here skin is kept to pale tones – the poor girl is probably allergic to daylight! Green is always a good choice for pesky-looking demons.

SCENERY

B y now, you'll have discovered that drawing sword and sorcery heroes and villains is a lot of fun, but it is only one part of the process of creating a fantasy art world. Without any background scenery, your character drawings are just floating around and are not really telling a story. Creating scenery is all part of the effect, so let's take a look at some step-by-step examples.

PLOTTING AND PERSPECTIVE

In order for the scenery you draw to be believable (yes, even though the landscape you are drawing may not exist, it is important that it looks as if it does), a good knowledge of basic perspective is necessary.

Study this simple diagram of a train track. Notice how the rails get closer together the further they are in the distance. The point at which they meet is called the point of infinity or vanishing point. The horizontal line is called – surprise, surprise – the horizon line. This is a very simple concept which can be applied to everyday objects and locations.

To start with, we'll take the basic cube shape and see how the rules of perspective work.

A 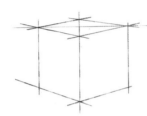 B 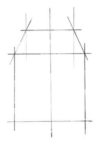 C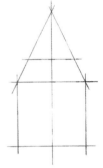

Take cube (A). If we turn it so that we're looking straight at it, flat on (B), notice that the two sides on the top seem to draw closer together, or converge, towards the back. If these lines are extended they will eventually meet (C). The point at which they meet determines the horizon line. This is called single- or one-point perspective because the perspective lines meet at a single point.

D 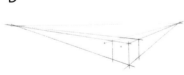 E 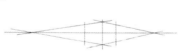 F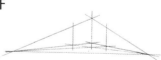

When we turn the cube slightly (D), so that the corner point faces the front, we get a two-point perspective.

If we change our viewpoint so that the horizon line cuts through the centre of the cube (E), and follow the converging lines to their ultimate meeting point, again, we get two-point perspective.

In (F), we've merely raised the object above eye level, but notice that the same rules still apply.

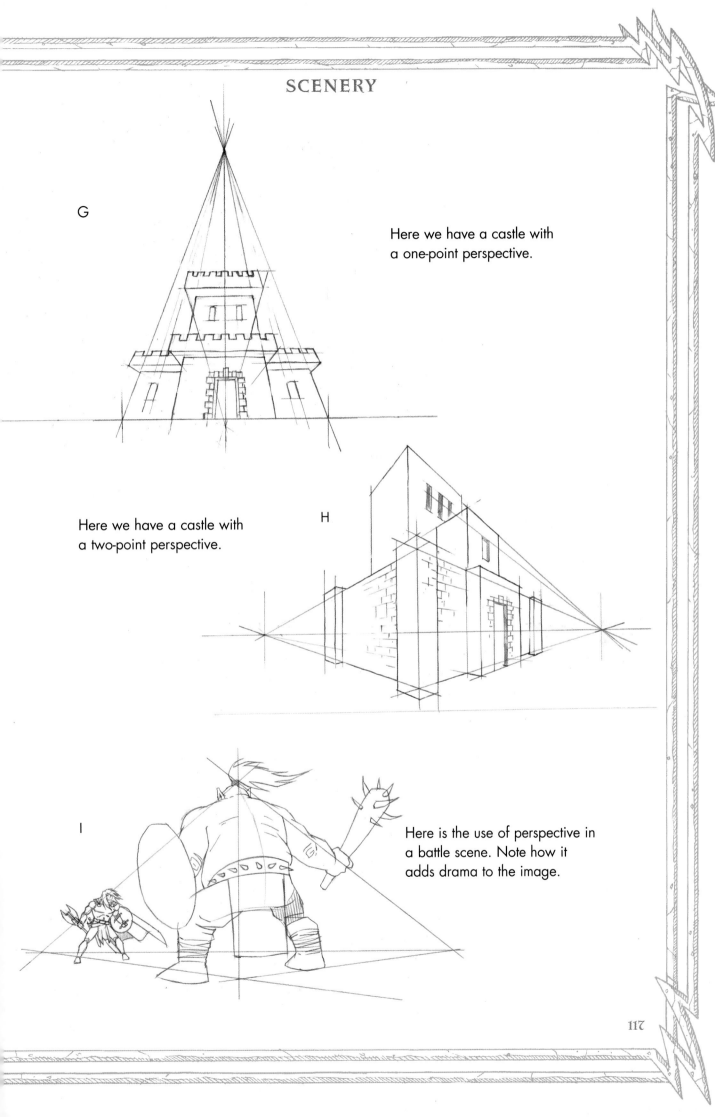

G

Here we have a castle with a one-point perspective.

Here we have a castle with a two-point perspective.

H

I

Here is the use of perspective in a battle scene. Note how it adds drama to the image.

FORESTS

Here is an example of an enchanted forest with a demonic tree creature as its focus.

1 Plot out some basic tree shapes. Note that the horizon line is just below the centre of the picture.

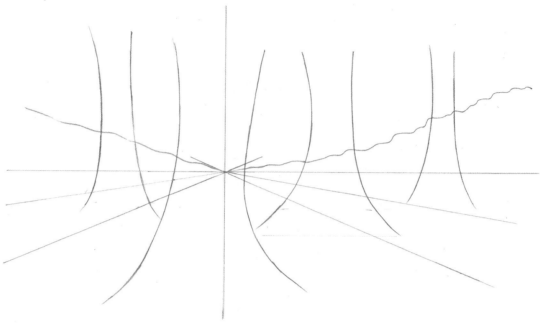

2 Start to flesh out the main tree with branches and the indication of a demonic facial expression.

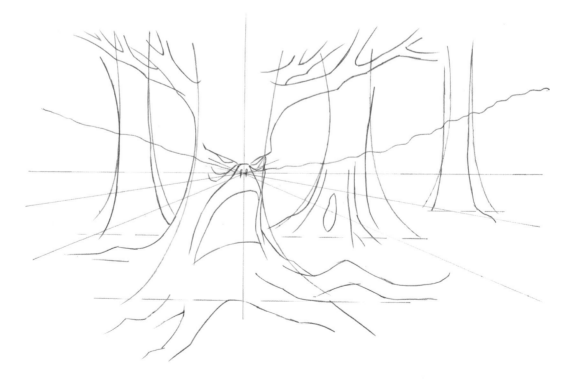

3 Now add leaves to the main tree and start to fill out the background with more trees. Add further detail to the face, and start to add bushes and clumps of plants to help break up the image and add interest.

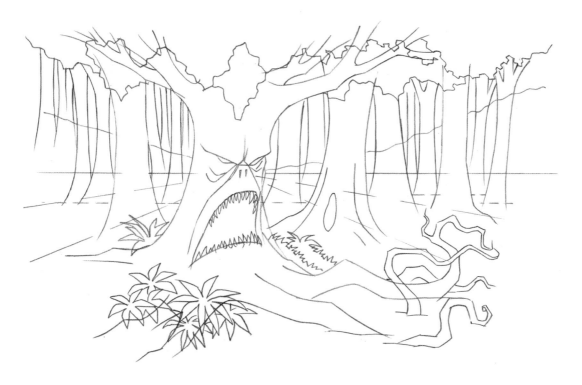

4 Here is a more complete pencil drawing with shading, detail and definition already in place.

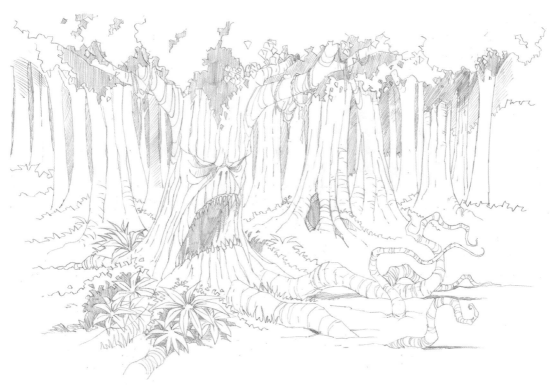

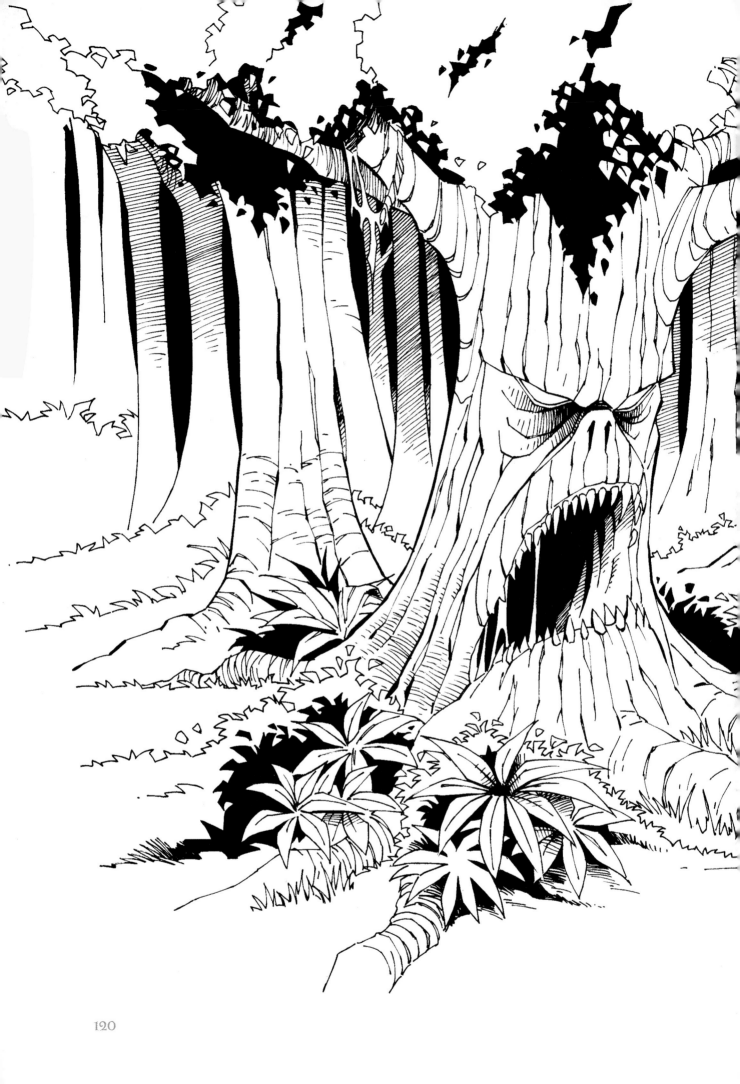

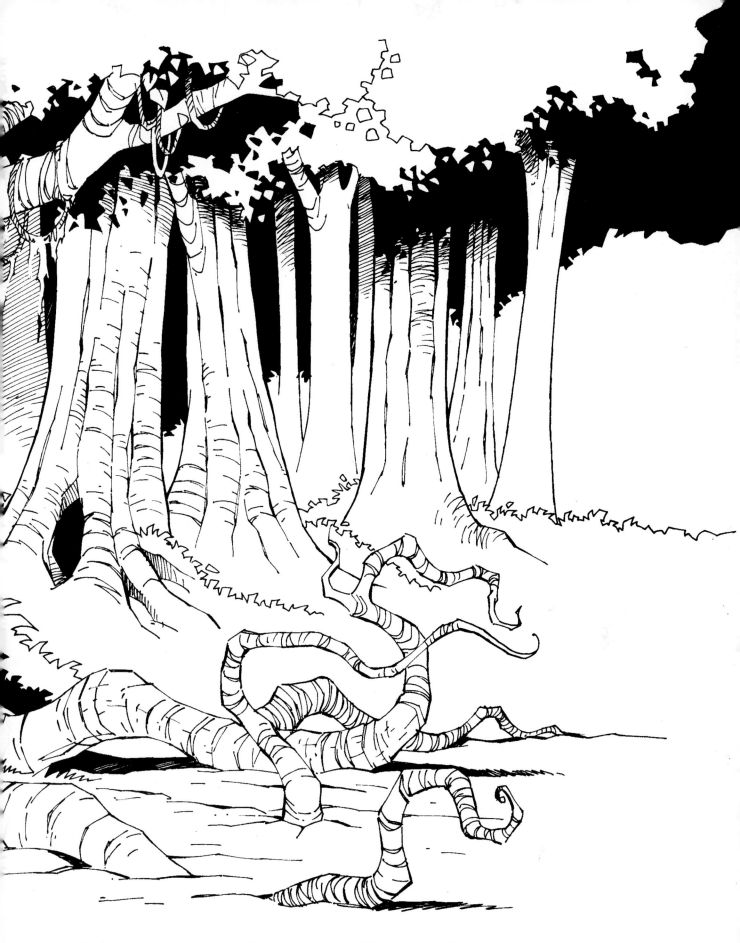

5 In this inked version, note that there is a lot of fine line work to shade in, which will add depth to the drawing and help to create a mid-tone range between the solid areas at the rear and the main details at the front.

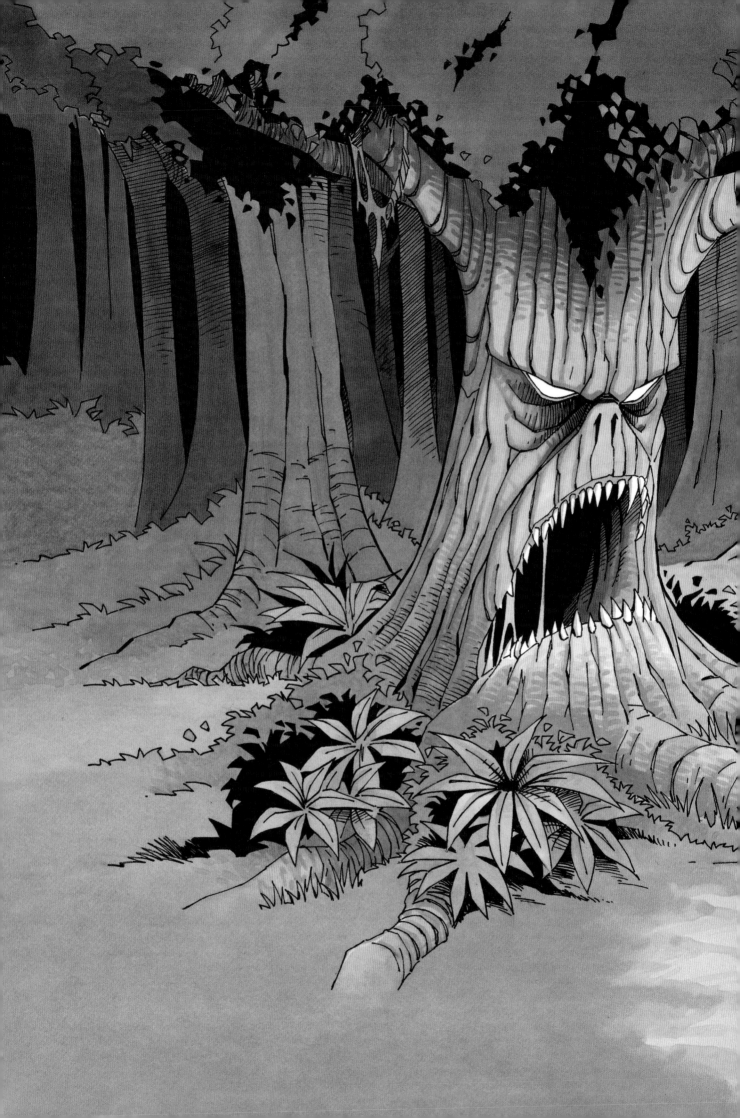

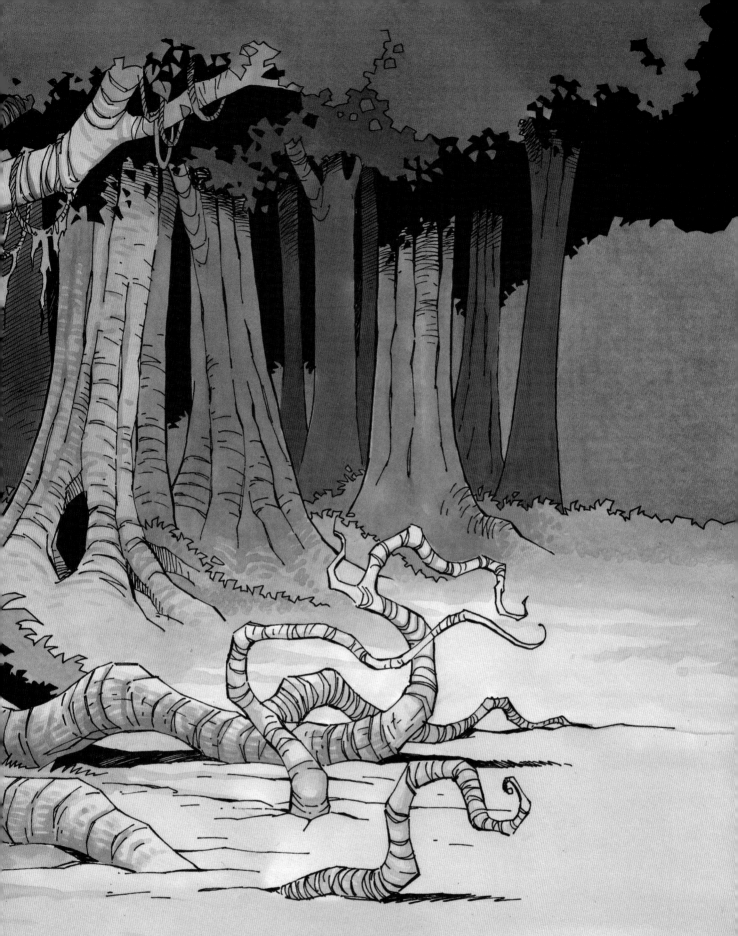

6 Here we have the colour version. You don't have to draw every blade of grass to convey a grassy area – detail has been applied where necessary to add credibility to the drawing, but not so much so that it looks overworked and visually confusing.

SWAMPLAND

Travelling over the wide open space of this swampland would leave anyone vulnerable to attack. By adding a swamp creature, we emphasize the overall menacing atmosphere of the setting.

1 Plot out some basic tree shapes. Note that the horizon line is just below the centre of the picture.

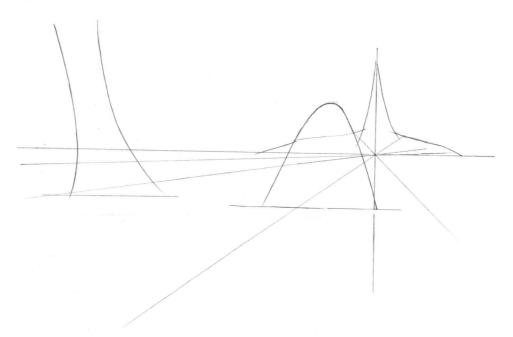

2 Now apply detail to the creature, adding tentacles, horns and add more surrounding plant life.

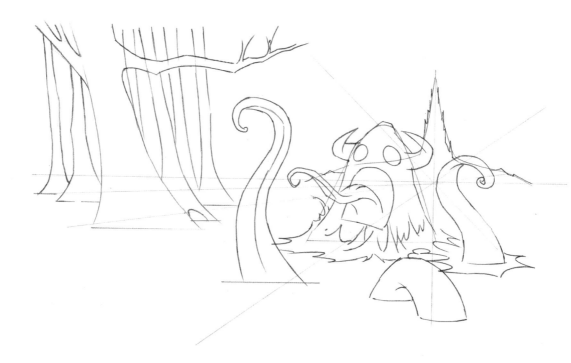

3 By adding more branches and tree stumps to the foreground, the scenery and the creature appear to merge into one.

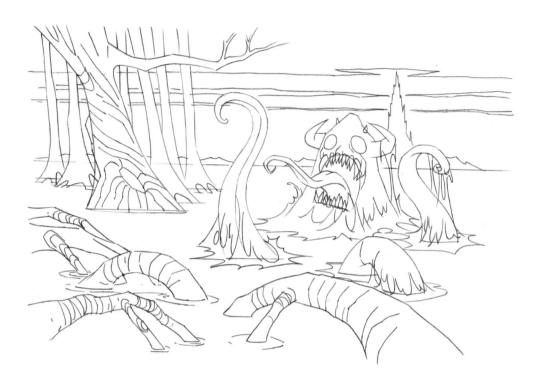

4 Here is the finished pencil drawing, featuring additional detail and shading to really help bring the scene to life.

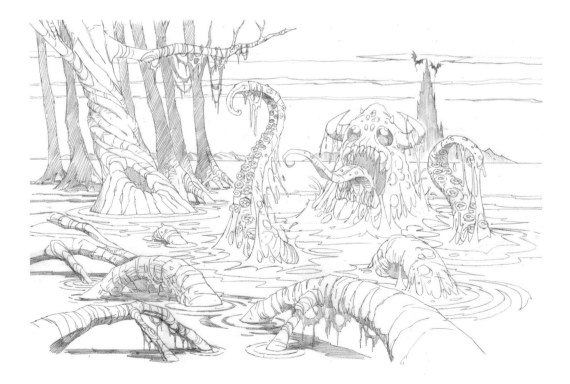

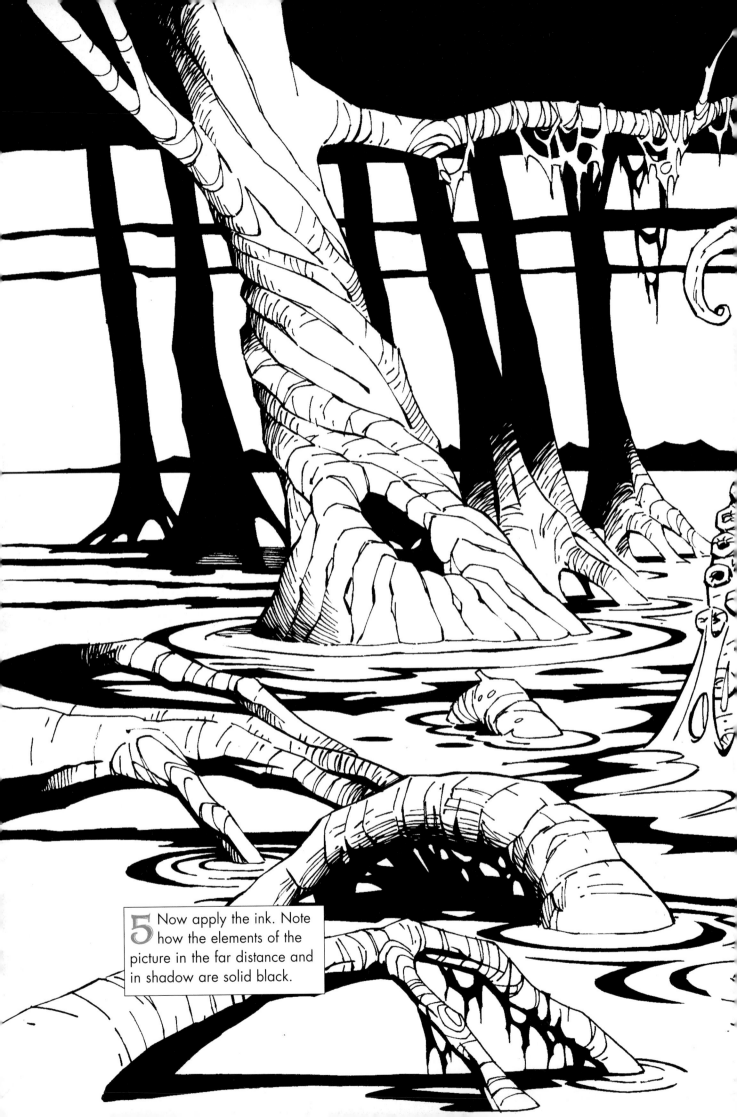

5 Now apply the ink. Note how the elements of the picture in the far distance and in shadow are solid black.

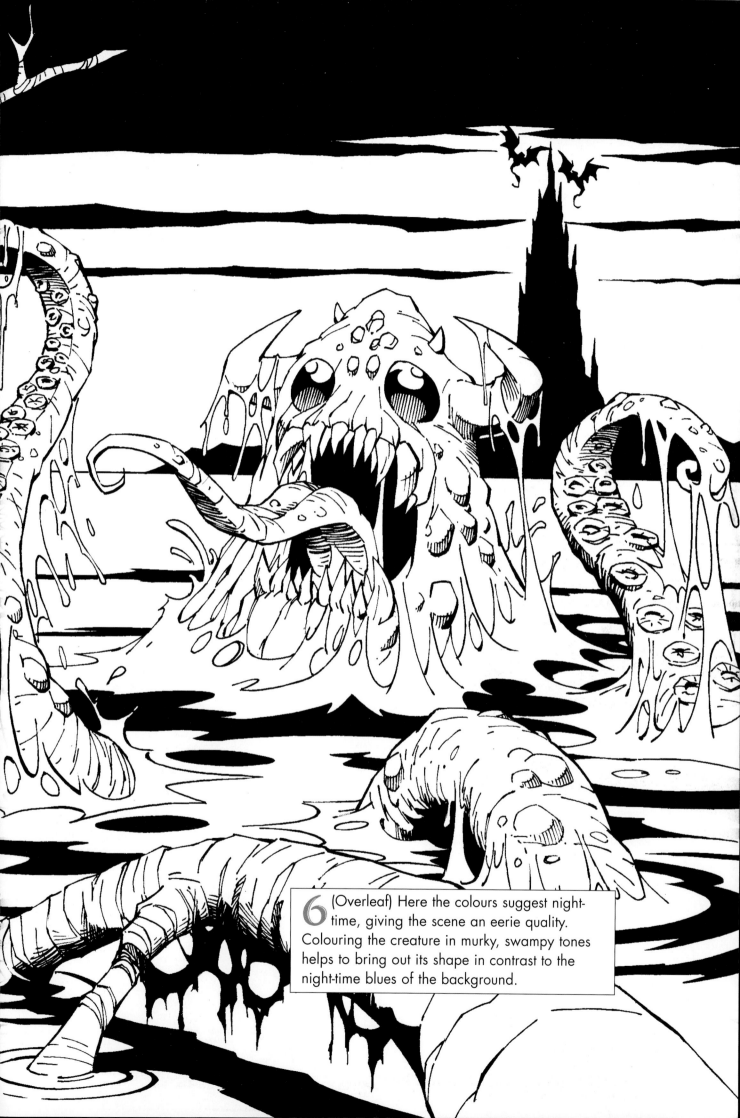

6 (Overleaf) Here the colours suggest night-time, giving the scene an eerie quality. Colouring the creature in murky, swampy tones helps to bring out its shape in contrast to the night-time blues of the background.

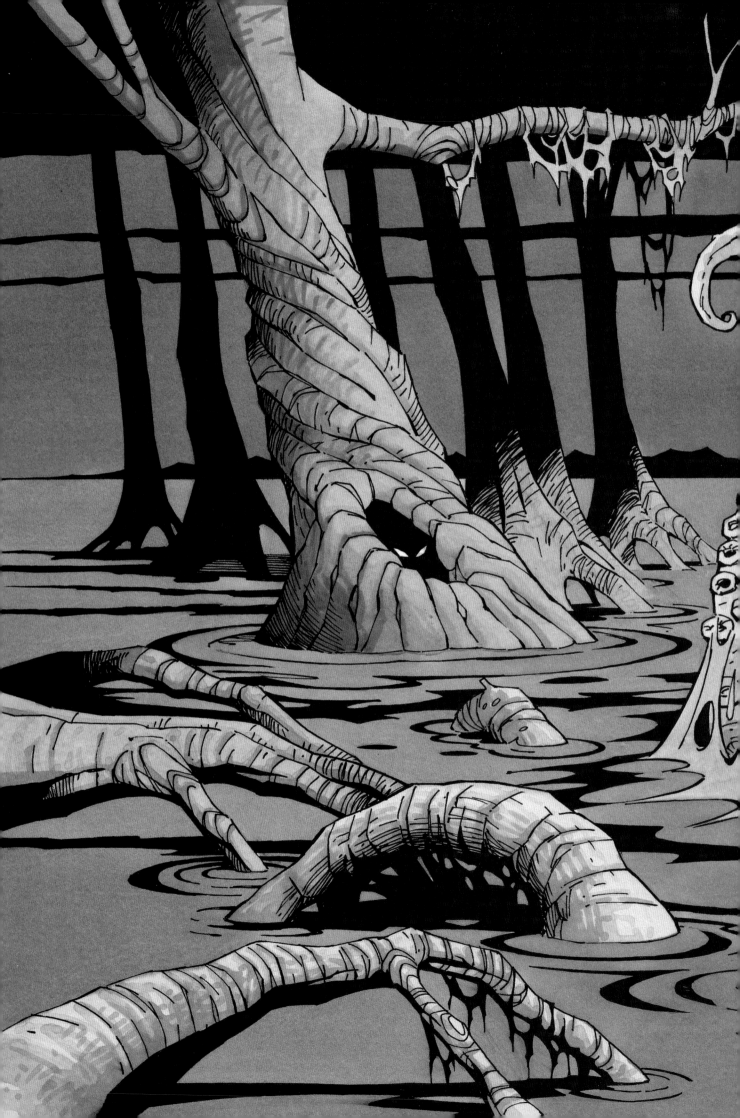

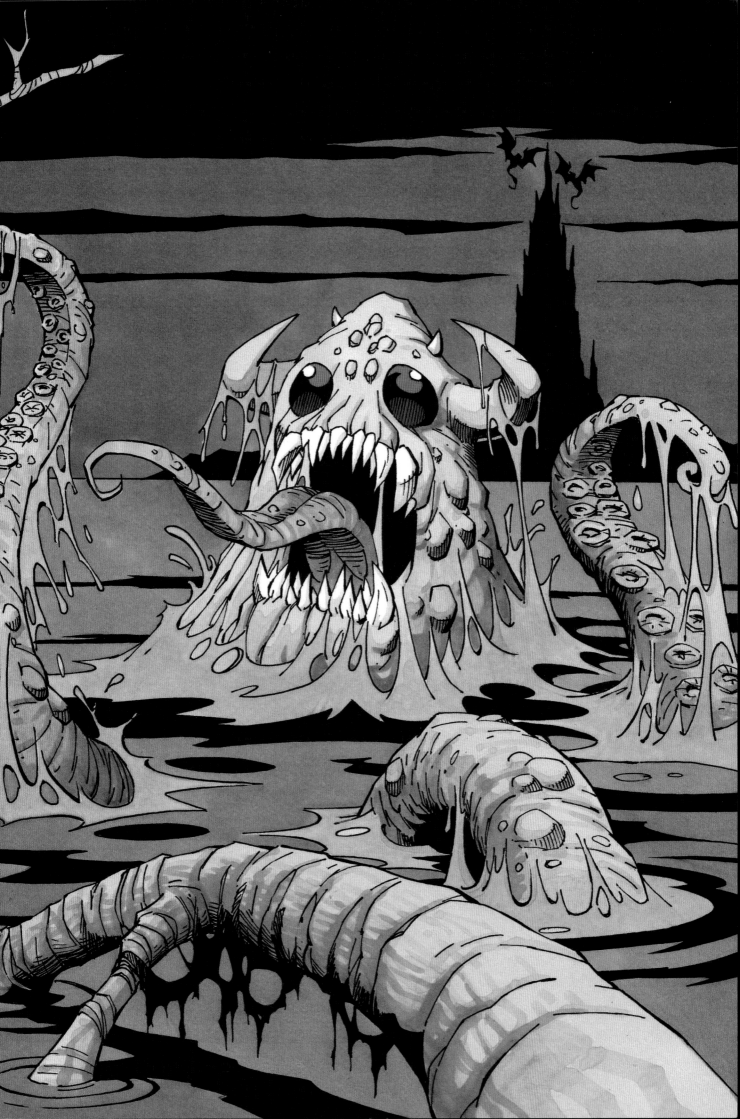

BATTLE SCENE 1

Here we have a female warrior in mid-flight, about to bring her trusty sword down on an orc. Notice the orc is in a defensive pose, raising his shield whilst bringing his other arm back ready for a counter-strike. This dynamic interaction makes the image more believable and exciting.

1 Although perspective is used here, it is not an essential ingredient as this image is virtually a straight-on view. But note that even the slightest use of perspective does help to give the image depth.

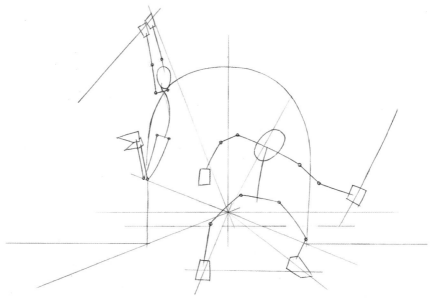

2 Add body form to the figures in the shape of cylinders and balls, and some stone or brick shapes to the wall.

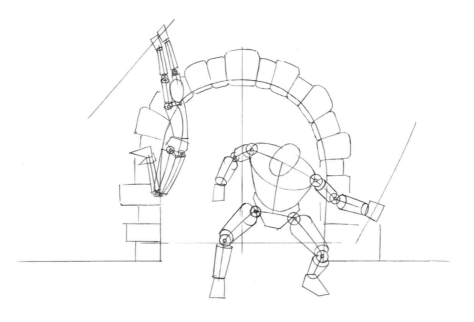

3 Now add facial features to bring your characters to life, and their clothing and weaponry.

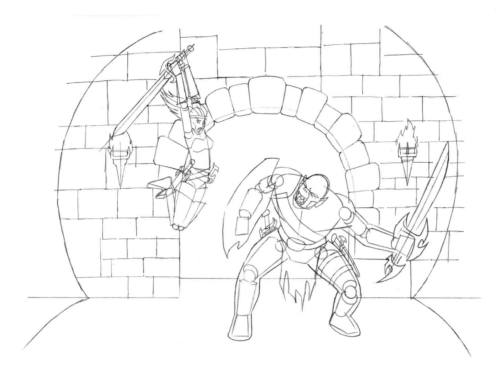

4 Finish off by adding refining details, such as texture and decoration, and cleaning up any unwanted lines.

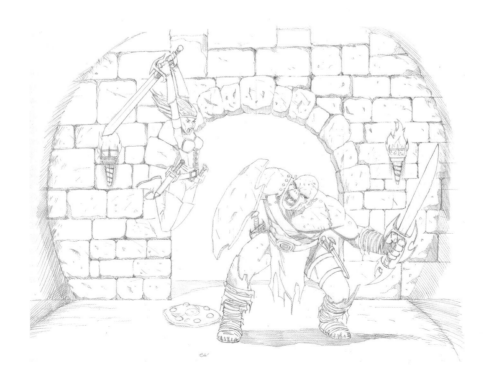

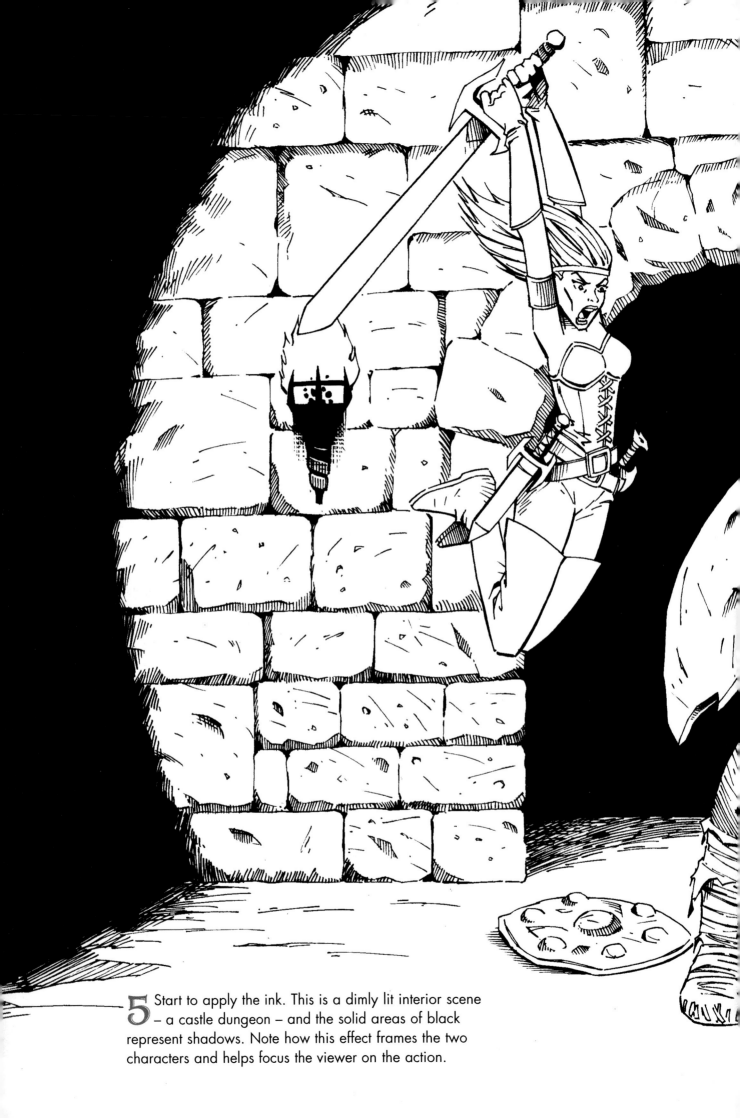

5 Start to apply the ink. This is a dimly lit interior scene – a castle dungeon – and the solid areas of black represent shadows. Note how this effect frames the two characters and helps focus the viewer on the action.

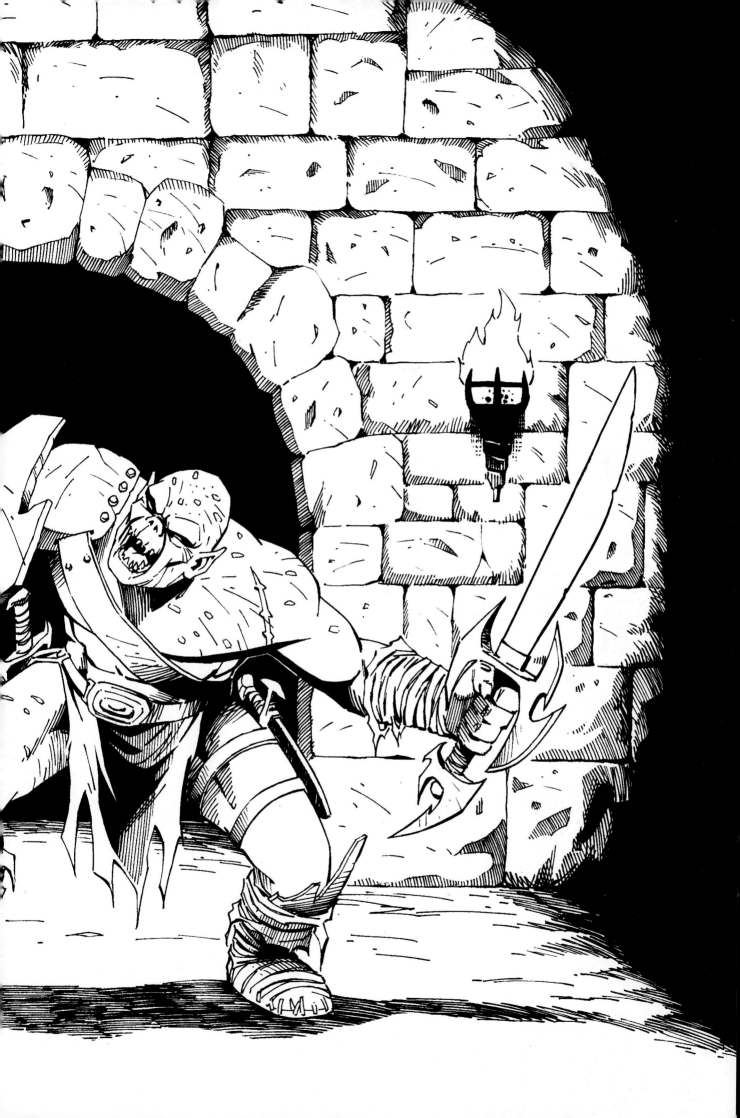

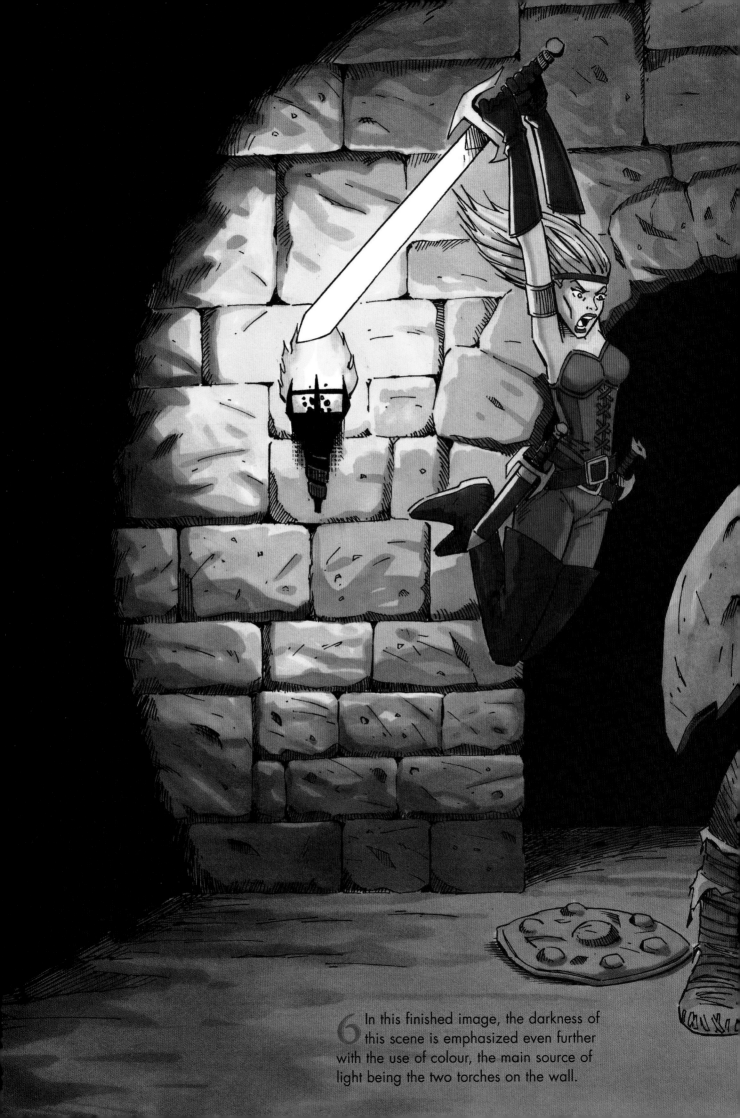

6 In this finished image, the darkness of this scene is emphasized even further with the use of colour, the main source of light being the two torches on the wall.

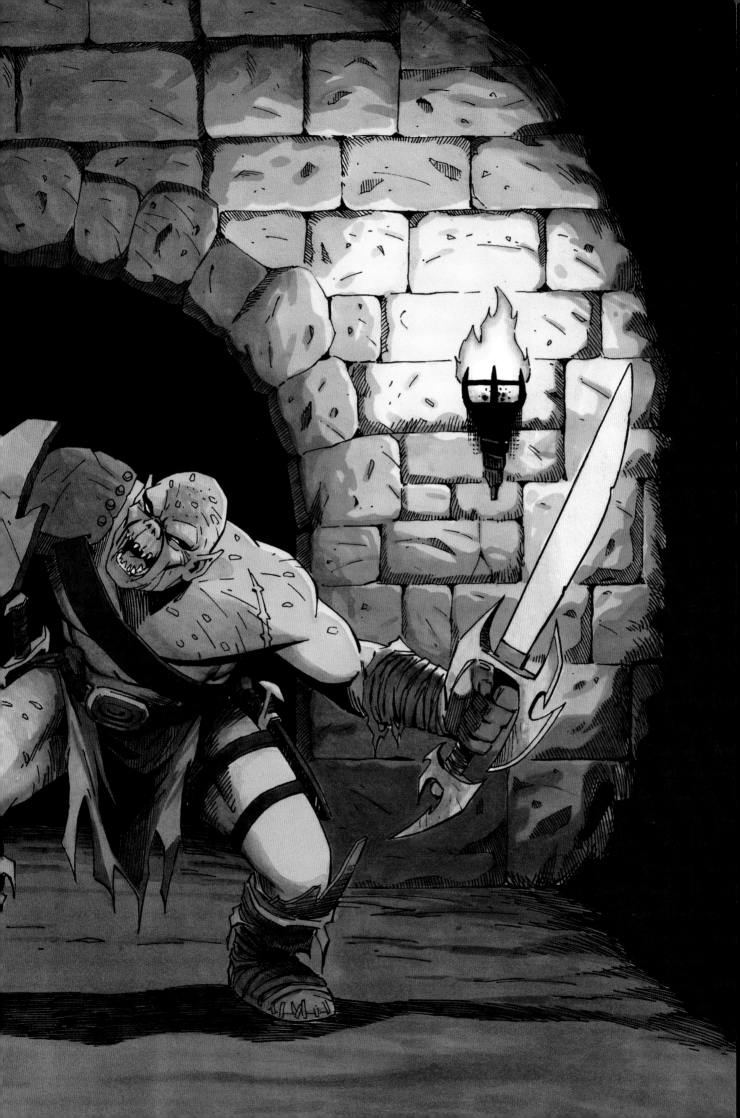

BATTLE SCENE 2

This scene depicts a warrior approaching a cave by a rocky bridge, only to find himself under attack from an orc astride a winged beast.

1 Plot out the landscape, identifying the three main points of focus: the cave, the bridge and the battle scene.

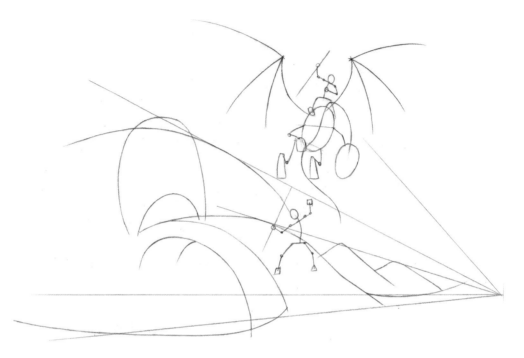

2 Flesh out the figures and add a bit more shape to the surrounding landscape.

3 Add more detail to the figures and the landscape, plotting out the craggy rock face and sketching in the dragon's facial expression.

4 Here is how the finished pencil drawing should look. Note that leaving the foreground bare creates a sense of the hero being stranded in a wasteland with nowhere to run or hide. He has no choice but to stand and fight.

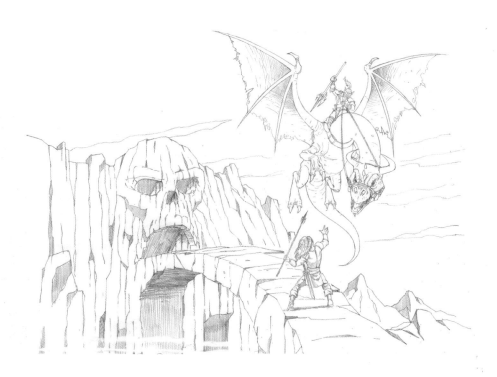

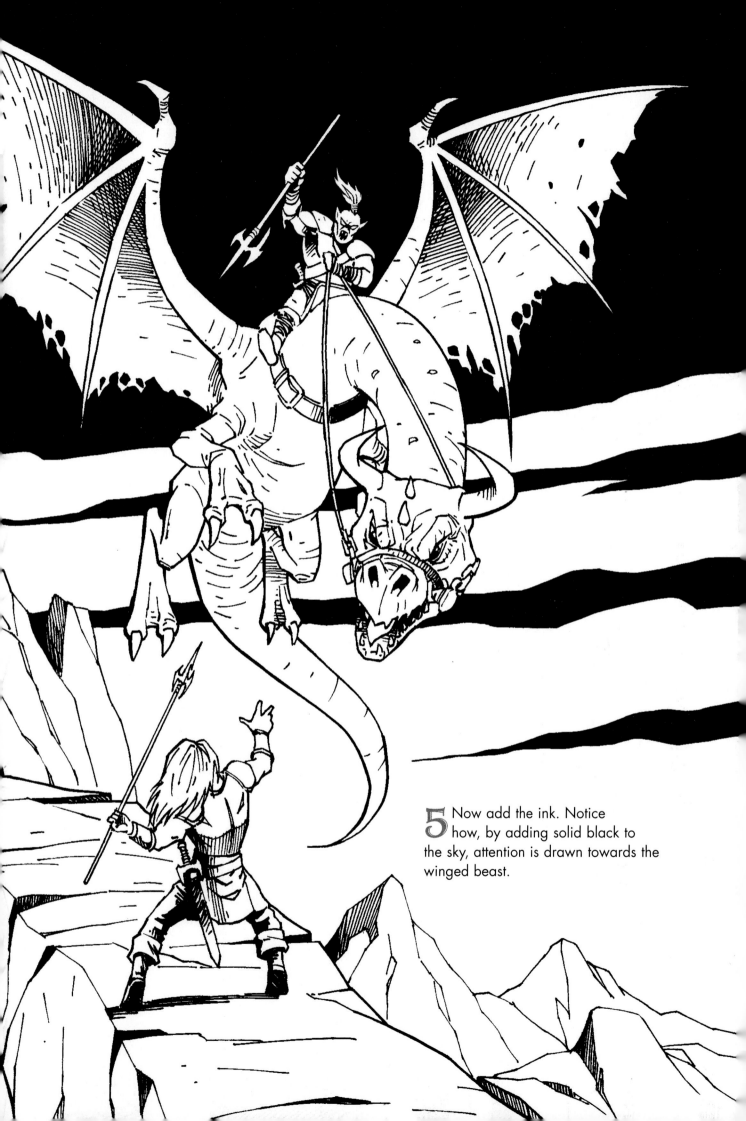

5 Now add the ink. Notice how, by adding solid black to the sky, attention is drawn towards the winged beast.

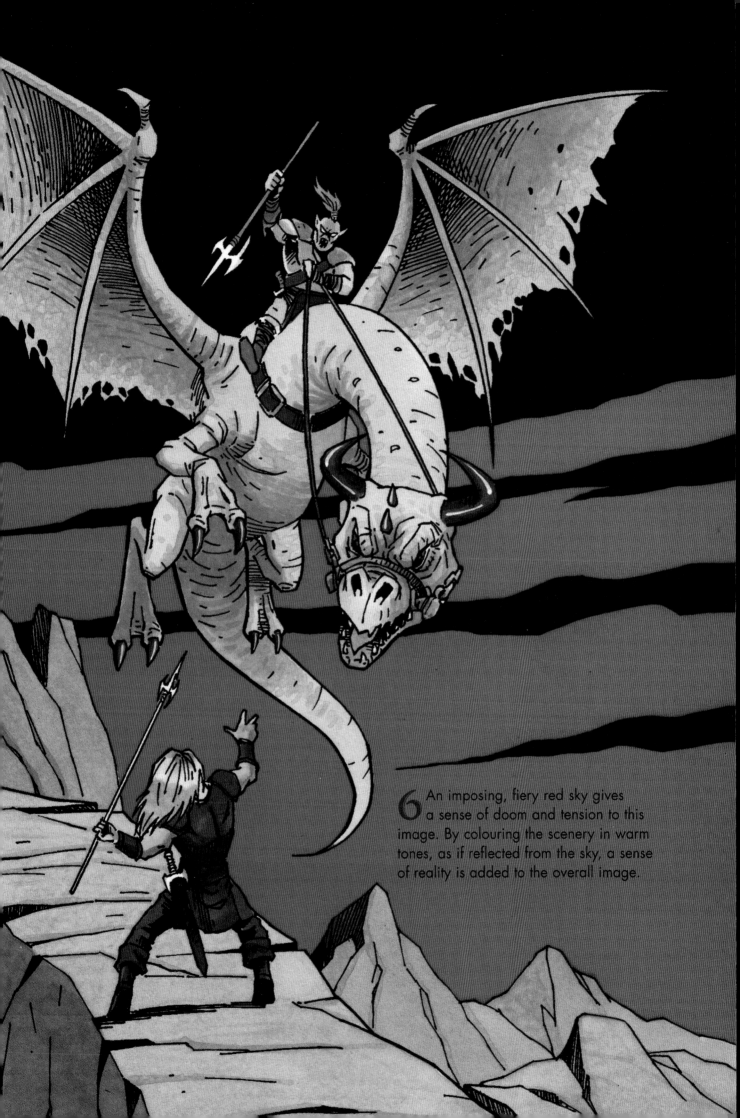

6 An imposing, fiery red sky gives a sense of doom and tension to this image. By colouring the scenery in warm tones, as if reflected from the sky, a sense of reality is added to the overall image.

COLOURING TIPS

COLOURING TIPS

Here are some simple tips to get you started. This sequence can be applied to the use of markers, inks or watercolours. A small section of this orc has been blown up so that the detail is more visible. It is advisable to lay your colours down in one continuous wash if you can, rather than break off halfway through an area.

1 Put down a blue base colour. Try to apply the colour as smoothly as possible.

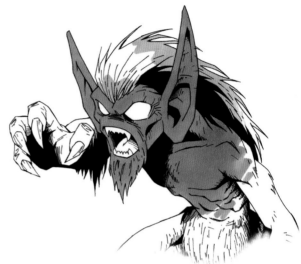

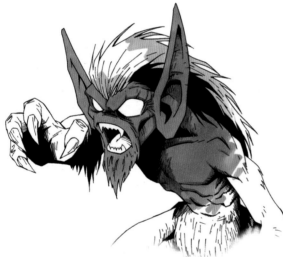

2 In order to build up variation in tone, you can either apply a second wash of the same colour (make sure the first coat is completely dry before applying the second coat) or go for a darker tone of the same colour range. Notice how the extra tone lends more shape to your image.

3 Now apply the same to the hair. You don't have to overdo it; applying just enough to the outer parts gives shape to what was originally a flat area. Add some tone to the eyes to give the impression of roundness.

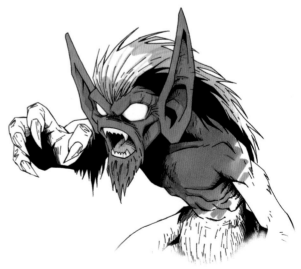

COLOURING TIPS

Again, rather than tackling the entire image (which could take up half the book) we'll just take a detailed section.

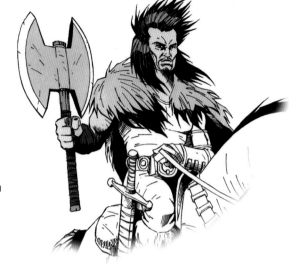

1 Apply flat colour to the axe using a mid-grey, then a mid-range skin tone for the flesh and a light brown – perhaps with a hint of green – for the fur. Achieving an uneven colour can help to create texture in materials such as fur, leather or rock.

2 Now apply a slightly darker tone to the axe. Notice how the application is uneven, creating the appearance of something hefty. Further shape is achieved by applying a slightly darker tone to the roots of the fur and to the skin. It's important that you don't go too heavy on your base colours, as this leaves scope for further tone, without making the drawing too dark and overworked.

3 An even darker skin tone has been applied which is then finished off with a mid-grey to darken the eyes. A light blue wash has been added to the axe, which makes it appear visually stronger and heavier. Also, a third, darker-brown tone has been added to the fur for extra interest.

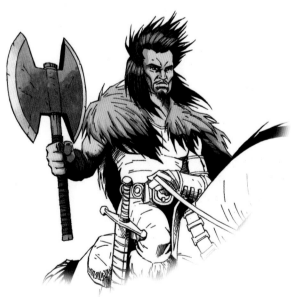

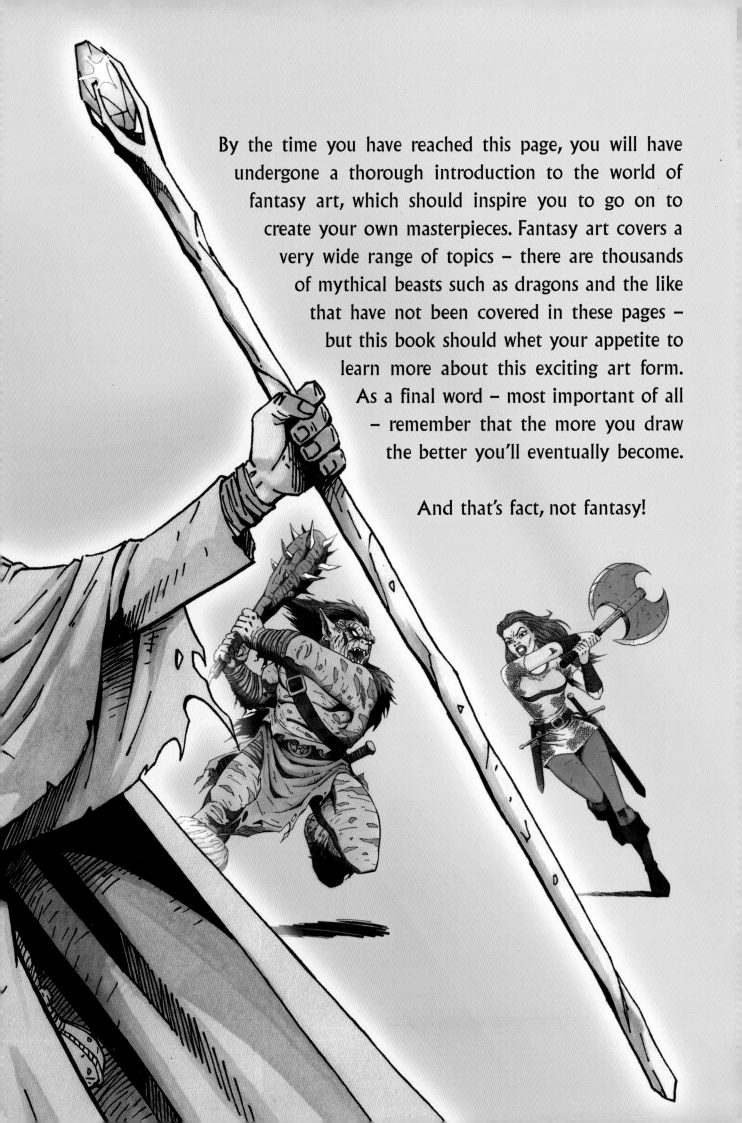

By the time you have reached this page, you will have undergone a thorough introduction to the world of fantasy art, which should inspire you to go on to create your own masterpieces. Fantasy art covers a very wide range of topics – there are thousands of mythical beasts such as dragons and the like that have not been covered in these pages – but this book should whet your appetite to learn more about this exciting art form. As a final word – most important of all – remember that the more you draw the better you'll eventually become.

And that's fact, not fantasy!